THE WORLD OF RUSSO

THE WORLD OF

OF

ONE HUNDRED DRAWINGS BY MICHELE RUSSO

Introduction by Jane Van Cleve

 PORTLAND, OREGON 1981

We gratefully acknowledge the cooperation of Arlene Schnitzer and the Fountain Gallery in making Mr. Russo's drawings available for this publication.

© Copyright 1981 by Michele Russo
All rights reserved
Library of Congress Catalog Card Number: 81-66524
ISBN Number 0-938996-00-2
Published in the United States of America by Bigoni Books, Portland, Oregon
First edition May 1981

CONTENTS Chiaroscuro in the Drawn World of Michele Russo [ix]

CHIAROSCURO
IN THE DRAWN WORLD
OF MICHELE RUSSO

THERE WAS a day when the drawings in this book were laid out edge to edge, row by row, on the paint-stained floor of Michele Russo's studio in the Mylar Building near downtown Portland. The artist, his white hair bristling, moved deftly from one image to another, re-ordering sequences into strands of work that reflected different facets of his absorption with the human figure.

For every drawing displayed, there were ten or twenty other drawings, each unique, dynamic and adventurous in its own way. These drawings, untitled and undated, numbered in the thousands. No outsider could doubt their reality as an independent body of work and a significant outpouring from one of the Northwest's major painters.

As a wintery sunlight blurred the pastel 'washes' which Russo had used "to destroy the harsh whiteness of paper," the artist himself looked bemused, surrounded by rectangular islands of light. "You know, I didn't really intend that these drawings be public," he confessed. For Russo, drawings are personal, intimate and informal. They are the journals he has kept, the notes he has scrawled, and the scratch pads he has filled, bridging that hazardous gap between experience and art.

The drawings also represent discrete moments in time when Russo was alone with the paper, the materials, and an open receptivity to an outside model or idea. According to Russo, this 'spontaneity' is essential to drawing. Even he will be surprised by the lines and shapes that just seem to happen when "he approaches things on a more raw level."

Typically, Russo draws on a soft rice paper that soaks up the ink. He favors pens with old nibs that bite into the paper's surface. Where the pen starts and where it goes will often depend on impulse, hunch, or intuition. Then, as the ink fills out the line, it tends to bleed or to congeal into blotches. Depending on the wash (whether coffee or watered-down paint), the ink changes color, often diffusing into a pale pink blur that blunts the edge of the line.

Russo enhances this sense of activity by drawing very quickly. Within a few minutes, he may draw several versions of the same figure on a single sheet of paper. Because, after "ten minutes the body goes dead," his compositions evolve on the spot. Thus,

when Russo describes drawing, he always leaves room for the influence of accident, mistake, or random intrusion. "I think that is what drawing is. Drawing is scratching and pushing and bleeding and making blots that add their own element to what is going on."

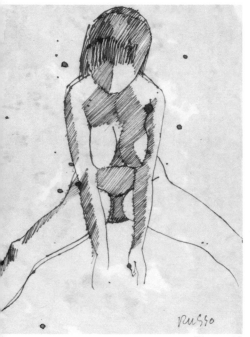

Figure 12

T HIS 'INNOCENCE' in Russo's drawing is a thing to keep in mind even as we consider his characteristic way with the figure. After all, as an artist, Russo brings an informed consciousness, a practiced eye, and a disciplined hand to his drawings. He is an expert at culling experience for its meaningful forms. Then, by his individualistic execution of these forms, he infuses visual imagery with an emotional content or energy.

Often this emotional content will be disturbing, given Russo's complex use of chiaroscuro, whereby he will intensify the tension between light and shadow for dramatic effect. While most artists use chiaroscuro as a device of clarification, to sharpen focus, Russo will often explore the opposite possibility, using shading to expand focus. Frequently, he will use high contrast, not to underscore the apparent, but to obscure the obvious, thereby confronting us with ambiguity. We'll sense a 'dark side' behind the 'bright' or clear image.

Russo's chiaroscuro can happen a number of ways. In straightforward figure studies, he may stress the difference between a heavily modelled nude and a nude described by lyrical, loopy lines. Yet the shaded figure will contain elements of lightness. The light figure will convey a sense of shadow. In drawings that involve symbolism or metaphor, Russo will use contrast to call our attention to paradox. We'll see the comic in the tragic, the tragic in the comic; the rational in the absurd, the absurd in the rational; the exceptional in the ordinary, the ordinary in the exceptional; or we'll see optimism implied by a negative 'dark' while the positive 'light' is annihilating.

In this regard, Russo functions like an ironist, exploring the co-existence of the clear and the 'hidden' as a way to evoke the complex, if contradictory nature of reality, subjectively perceived. Thus, in an apparently simple drawing (Figure 12), we may see a lovely female nude, described in straightforward lines with a balancing shadow, this simplicity convincing us of the body's unselfconscious availability and openness.

Then, just as we have assumed a state of directness, we'll notice some slight detail: the armored position of the arms or the head averted or the pelvis so fiercely articulated as to suggest an impenetrable thicket or wall. Suddenly, the body's presence becomes furtive. The impression of autonomy has been subverted by an element of vulnerability and privacy. The further irony is that, while our 'knowledge' of the figure has been heightened, we begin to suspect what we really know.

Russo does not rescue us from perplexity. What he does acknowledge is that ambiguity is fertile ground from an artist's point of view. As he explains, "In our society, ambiguity is shunned. It's assumed to be a weakness, but I think of ambiguity as a path to growth and understanding, a form of freedom, and an escape from the stereotype.

"I am always struggling with ambiguity, but I also rather

believe in ambiguity and in the contradiction in terms when you put things in a very positive, bald form even though you have experienced these things from some mysterious, formless origin. In other words, you are trying to state what doesn't seem to want to be defined, yet you are trying to state it with great definition."

In this regard, it becomes appropriate that Russo, the artist, function somewhat like a saboteur, undermining our preference for the recognizable by making the familiar foreign. It is also appropriate that his chiaroscuro highlight the controversial in art because life is controversial: an ongoing play of 'hide and seek' with elements of light and shadow. Finally, it becomes appropriate that his drawings suggest struggle, pressing for a new reality that transcends the safety of an objective, dispassionate presentation.

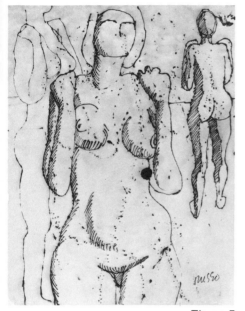

Figure 5

TO SOME extent, controversy comes naturally to Russo, given his Italian background. As he puts it, "Not only am I Italian, but in many ways I feel Italian in the sense that I live with conflict. I think Italians have this extraordinary ability to combine lucid rationality with irrationality. Out of the conflicting aspects of life, they create wholeness by putting opposites together. It's sort of a dualistic way of existing to make oppositions create the whole or the unity."

Here the words *wholeness* and *unity* are important because Russo's drawings, when viewed as a total statement, convey a holistic view, where the integrity of the figure becomes the crucial issue. Needless to say, Russo has an affinity for the classical tradition with its emphasis on humanism and the centrality of man in the universe. Specifically, the nude as an art form was invented by the Greeks, who saw the human body as the perfect external manifestation of the ideal human potential.

Russo breaks with the classicists, though, in his emphasis on the subjective. His nudes are more existential and 'in process.' Given the ongoing interchange of light and shadow, their formality is constantly at risk to the forces of change, choice, and dilemma. Even though archetypal (lacking facial features, individual idiosyncrasies), his figures will convey struggle, mainly because Russo has concentrated on "gesture."

"And by gesture, I don't necessarily mean what the figure is doing, but the whole expression implied in a particular attitude. Often it is an awkward gesture, where it's the strange position of the arms or the legs or the hip, maybe. The gesture of the whole figure says a great deal to me emotionally. I suppose that's one reason I've never paid a whole lot of attention to heads and faces. I find the whole body exciting," Russo has said.

Certainly we sense this excitement in the drawing of three women, where a circular tension connects the figures in an undetailed context (Figure 5). The foreground nude is treated frontally with a disarming directness. Despite her artificial pose, we feel 'up close' to this woman, our view so intimate that she appears to be looking over our heads. Her breasts, her abdomen, her waist and hips, her wide pelvis and strong thighs have been articulated to convey contour and dimensionality. The one quality we believe about this woman is her physicality. She is earthy, sexual, and not nearly so 'distant' as the woman on the left, so ethereal as to float off the page.

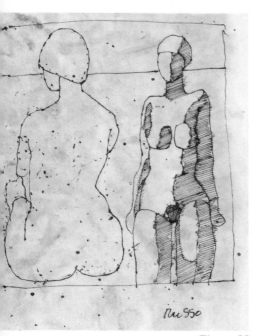

Figure 38

This second nude is very beautiful but aloof, like an elegant Greek goddess. Russo's use of lyrical lines enhances her poetic and pensive qualities. Her columnar authority is tempered somewhat by a graceful tentativeness, but she seems 'of the mind,' a ghost or a shadow. She conveys a lost or abandoned presence as does the third nude, truncated in scale, who seems to be retreating in a purposeful direction, away from us.

Now, here's the irony. Because these figures occupy the same spatial frame, we tend to assume they are related in time as three women who are strangers and not very interested in each other. Russo has explored so much discrepancy in the qualitative differences of each figure that what we don't assume is one individual, seen from three different perspectives. Once we do recognize the three figures as one, the implications of alienation become intriguing on a psychological level. We have a sense of dramatic "turning," whereby the drawing transcends the limits of a static medium.

It is this possibility for illusion or metamorphosis that Russo explores when he does not impose an outside narrative structure, but instead allows the drawing to evolve its own subject matter. Furthermore, by manipulating scale, he has probed a reality both 'real' and 'dream-like,' where rational and irrational elements work on our response. The 'whole' we see is really implied by three fragments of conflicting intensities. Yet, the drawing as a unified statement becomes much more interesting because our need for logic and clarity has been both whetted and thwarted by the presence of mystery.

In fact, many of Russo's nudes will evoke the wisdom of Francis Bacon, who observed in the sixteenth century: "There is no excellent beauty that hath not some strangeness of proportion." In Russo's case, this strangeness is often an awkwardness in the figure about space, a kind of tentative footing in the landscape.

Often this tentativeness is conveyed by chiaroscuro. Thus, in a drawing of two women sunbathing (Figure 38), the figure on the left, developed entirely by curved assertive lines, is both voluptuous and solid. We see her from the back, which is often a lustier view, particularly when the buttocks are so tangible and when the line from hips to back is sensual and appealing. We see heavy thighs, a strong neck, and an elegant head. In fact, the weightiness of this figure gives her a formal authority that is almost monumental. We sense she could go on forever, given her substantiality as a kind of earth-mother.

In contrast, the woman to the right seems on the verge of disintegration. Russo has used intense shading to emphasize pools of light, obscuring a sense of the body's firm edges. Although we can see detailed modelling, we also see areas of light and shadow so abstract as to be amorphous. Not only is the body fragmented by light, but it is amputated by the paper's edge. This figure seems much more 'tense' about her status.

Again, we are actually looking at two studies of the same model, but they seem almost opposites: the one, stable and archtypal and the other, conflicted by change and evolution. Yet the second figure seems "alive" because her reality is controversial. The first figure seems innert and implacable, like a rock or an ideal.

Another value Russo uses experimentally to convey the

tentativeness of the figure is scale. In Figure 51, for example, the nude on the left demands our attention. Her vitality is almost atmospheric, the light areas of her body in athletic balance to the dark areas. She confronts us with her presence. In contrast, the nude to the right seems much less confident about her space and is consequently more fugitive. Her smallbreastedness suggests an adolescent awkwardness, reinforced by the body pitched in one direction while the head is distracted in an opposite direction. While the first figure is formidable, the second figure conveys a charming failure of presence.

However, the implications of space are also intriguing in this drawing. Are the figures the same? Are they mother and daughter? Are they even together? Even if related, the two figures seem separated by a space of indeterminant distance, given the difference in scale. This ambiguity both foils and intensifies our emotional scenario.

Russo is sympathetic to this kind of dilemma. "I will notice myself in some drawings a certain discrepancy in the space or in the distance between figures," he has observed. "This discrepancy seems to have an unreconciliable character to it so that the figures, while they are together, are also isolated from each other. While they're walking toward each other, they may also be walking away from each other."

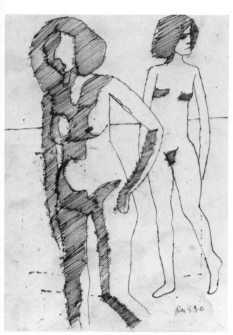

Figure 51

NOW, WHY is Russo so interested in the tentative status of the figure? Why does he cultivate the foreign, where the figure does not seem quite at home in space? Or why does he emphasize the refugee aspects of the figure, who then becomes a stranger, full of reservations, not only about space but about the body's autonomy?

Artists resist importation of their biographies. Legitimately, they recognize that their work must speak on its own terms. Nevertheless, Russo's personal history is so complex as to shed light on his interest in the figure as at once a *stubborn* loner and an *awkward* joiner.

Russo was born in Waterbury, Connecticut, in 1909, in a neighborhood filled with refugees from Europe. His own parents were Italian immigrants who, even as they embraced American dreams, still maintained close ties to their homeland. Then, when Russo was five years old, he was taken by his mother to Italy for a short visit which became a protracted exile, after the outbreak of World War I.

Ineligible for Italian public schooling by virtue of his American citizenship, Russo became the charge of a Catholic priest who happened to be an artist. Obviously there were positive aspects to this 'foreign' identification. Not only did Russo develop a strong love for the art and culture of Italy, but he got into the habit of drawing every day. Furthermore, he was exposed to a life-style of creative expression long before he had any self-conscious ambitions to be an artist himself.

Not surprisingly, though, by the time Russo returned to the United States at age ten, he was bound to feel estranged in his own country. He spoke very little English. He had developed passions for the wrong things, and he saw himself again as "a bit of a foreigner."

Given his shyness and sensitivity, he had a hard time passing for 'the all American boy.' Instead, his closest friendships were formed with other displaced ethnic intellectuals, many of them older and politically sophisticated. These refugees developed in Russo a strong social conscience and an acute sense of historical perspective.

Thus, by the time Russo finished highschool, he had absorbed a dual consciousness shaped by two citizenships, both of which he embraced with certain reservations. Already, he had decided that a life of art, which was personal, did not preclude a life of activism, which was social. From his associations with Jewish socialists, Italian anarchists, and Lithuanian exiles, he had developed a strong identification with the working man and minority causes. Yet his artistic talent — an elite quality — took him to Yale University, a bastion of conservative erudition.

Russo himself became a 'stubborn loner' and 'an awkward joiner' when he entered Yale as a candidate for the Fine Arts degree in 1930. At this time, art education in America was very traditional. Students were trained to become highly proficient copyists of the techniques used by the Old Masters. Needless to say, Russo, the individualist, rebelled against the constraints of such a rigid curriculum. He questioned the sterility of the artificial 'set up,' where the young artist would spend two hours a day, drawing a model who maintained the same pose for a week.

At the same time, Russo, the awkward joiner, felt great empathy and love for the emotional content of the work by the Old Masters. He admired the heroic humanism conveyed by art that transcended local implications to deal with beauty and truth as universals. But how does one express the heroic possibility, not with idealized saints or romanticized nudes, but in democratic terms that would address the plain, ordinary figure? By his decision to become a figurative painter, Russo took on this challenge. Important models, then, were artists like Henri Toulous Lautrec and Hilaire Germain Edgar Degas, who had pioneered a new intensity about street people, shown in their gymnasiums or cafes.

"I have always admired the drawing style of Degas. I admire Degas' whole attitude toward the human figure. He was very absorbed with a kind of animal-like forcefulness and movement in the human body. I think he got that quality from drawing horses. They were anthropomorphic horses. They're very elegant. They have beautiful limbs. They even have sexuality," Russo has asserted.

"When Degas moved to the figure, he did the same thing with human subjects. Degas' drawings can be very deceptive because on the surface they just look very beautiful, but there is a kind of cruel, piercing powerful astuteness to the drawing. For example, those dancing girls! They are treated very much like the horses. Their limbs are distorted. Their knees are bony, and their movements are awkward. You know, even their faces! Degas gave them huge nostrils from breathing."

Russo's interest in the beauty of the energized, expressive figure had become an aesthetic commitment by the time he graduated from Yale in 1935.

However, the terror of the figure loomed as an alternative vision once Russo joined the ranks of the unemployed at the height

of the Depression. In the same year, he had married Sally Haley, a young painter. Both artists could feel the cold winds of oppression and revolution.

Both painters recognized the displacement of the individual in this country, given the upheaval of economic collapse where so many people were left stranded from their homes, their work, and their personal dignity. Meanwhile, with the fall of Ethiopia, the Spanish Civil War, the ascendency of Hitler in Germany, and the stranglehold of Mussolini in Italy, Fascism was on the rise in Europe. Both the freedom and the power of the individual were critically at stake, a fact which Russo recognized by the time he became involved in WPA projects for the state of Connecticut.

Yet, ironically, this time of great negative implication was also a time of ferment and creative volunteerism, where artists were not relegated to garrets or ivory towers, but instead could assume an active role in shaping a new culture. Then, the dilemma was how to be an artist and an activist without compromising the integrity of either position.

Russo resolved this conflict his own way. During this period, "social realism" became the aesthetic vogue, a politicized art which Russo eschewed even as he participated at a grass roots level in political reform through the Peace Movement, the early Feminist movement, and the labor movements.

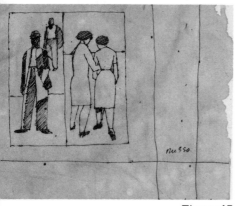

Figure 45

We sense Russo's adroit stancing as "stubborn loner" and "awkward joiner" again in 1937, when he went to Colorado to study figurative painting with George Biddle and Boardman Robinson. In his 'spare' time, he helped to organize migrant Dust Bowl victims under the assumed name of Michael Reese. Then, during World War II, Russo was willing to put his painting aside to work first as a chemist and then as a visual planner for the U.S. Rubber company.

However, after the war, when a violent schism developed in the art world between the Abstract Expressionists and the Traditional/Naturalist painters, Russo remained stubbornly faithful to the figure. In fact, throughout his life as artist, teacher, citizen and activist, Russo has recognized that the jeopardy to the figure in art is really an external metaphor of the jeopardy to the individual in society, given trends toward de-humanizing technologies and anti-heroic polemics.

"The Twentieth Century is really the century which emphasizes and dramatizes and is struggling with the importance of the individual," Russo has stated. "I think the figure has lost its central position both in modern art and modern society. I think there is a great deal of embarrassment attached to the image of what the human figure is. Who is he or she? In the modern world, the human figure has been discredited and has lost heroic significance."

RUSSO'S CONCERN for the footing of man is portrayed graphically in drawings where the people can seem anonymous and outcast (Figure 45). They are even strangers to their own skins, hidden in street clothes, isolated in closet-like ghettoes, and separated from us by margins or moats of space. In one frame, we see two men, reduced in scale, who seem frozen in their impotent stances, with a 'dark-faced' impassivity. Meanwhile 'next door,' two women help each other, their backs to us as if they don't expect our interest or

sympathy. What we sense is a serious constraint of expressiveness, a dispairing loneliness, an absence of sensual tension or psychic energy. These figures seem boxed in and helpless at the periphery of their worlds.

Yet, in another strand of drawings, Russo treats the same theme — the figure jeopardized — with an almost passionate violence. Some of his most powerful studies show the female nude in an anguished struggle for footing, where the inner urgency is so intense as to defy the intelligibility of form. In these drawings, we can also observe Russo's talent for reversals through chiaroscuro. In the textured "shaded" areas we sense the life and power of the figures. In the 'lightness' of surrounding space, we sense an annihilation, whereby bodies have been crippled, cramped, or mutilated by an oppressive force we sense, but don't see.

Meanwhile, margins become important: external margins that amputate feet and hands, but also the body's margins, transcended by the figure's spiritual vitality. Thus, two figures, so disjointed and twisted as to appear dismembered (Figure 22), writhe in caged space that prevents full stature and connectedness. Yet there is triumph implied in the elongated arms outstretched in gestures of fierce rage or protest. We sense something hopeful from the negative energy of suppression.

In fact, Russo will often associate the 'dark side' of experience with the figure's frontier. As he puts it, "Actually I am a person for whom the negative implications are more important than the positive implications. The positive implications are usually the popular implications, the implications that meet with social approval. But I have also and always been fascinated by malad-justments: by fears, frustrations, improprieties, and some of the less understood things in life.

"To me, the emotional areas identified with rage, fear and anger convey the unknown. When you paint or draw, you are really trying to reach into the unknown. I think the unknown is the greatest resource that a person can have."

Certainly Russo's nudes, when seen as a group, undergo a transition, whereby the struggling, timid, tentative figure evolves into a nude of heroic potential, verging on the mythic. In fact, we begin to associate the woman with the essential evolutions having to do with nature, birth, creation, sexuality, nourishment, and our 'animal' survival.

A stunning example would be the nude holding her breasts (Figure 4), who is full-bodied and powerful, the light and dark intricately balanced, and her stance conveying a sense of autonomy both self-reliant and assertive. This woman emanates a sense of relaxed pride in her capacity to offer erotic pleasure and maternal sustenance. In her physicality, she has much more in common with a primitive fertility goddess than with the typical goddess of 'civilized' western art, who modelled love as either sacred or profane.

A beautiful pagan sexuality is also conveyed in Russo's loopy "beach" drawings (Figure 78), where the female figures have a kind of Amazon grace, both liberated and playful as they bend, stretch, leap, cavort or brood in what seems to be an idyllic landscape. Any sense of risk has been masked by Russo's lyrical penwork even though the figure's balance is still the central issue.

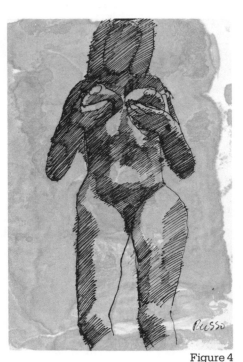

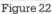

Figure 22

Figure 4

At what point does the body fall out of grace into a tumble or a pratfall? Certainly we see a couple of nymphs come close, their poise fragile and poignant on an unclear tightrope. Meanwhile, Russo has indicated enough horizons, margins, ceilings, and innocent clouds to convey these buoyant figures are earth-bound. In Russo's world, the human world, no figure has carte blanche just to be.

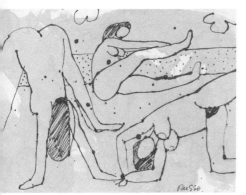

Figure 78

I N FACT, Russo doesn't see the figure as simply 'individual.' Just as important are social implications, which Russo explores in those worldly drawings he describes as "topical." In one group of drawings, he has explored economic stereotypes involving workers, but in another group of drawings he is interested in the light and shadow aspects of sexual stereotyping.

As if to emphasize the structure of the social figure, Russo's drawing style becomes more architectural, the figure defined by more corners and edges. Also, he will deliberately manipulate scale to allow the rational and the irrational equal play in a context increasingly theatrical. These drawings can also seem more formulaic when, in fact, "formula" and "style" are the issues Russo raises through conventions associated with theater.

An early example of this shift would be a documentary drawing of a man engaged in labor (Figure 48). Both the man's presence and his gesture are monumental. We don't know what he is doing exactly. However, we do recognize the movement of swinging a tool as timeless and no doubt universal. Clearly this figure is heroic, "a world unto himself," a pillar of the community and a model to his fellow men.

In fact, the man's centrality is so undeniable that we barely notice the nude woman on the side-line, who seems incongruous, out of place, and irrelevant to his enterprise. Her reduced size implies a limited power even though her sexuality and earthiness represent an alternative focus. Here, the irony is that 'the natural body' exists as an intrusive distraction. The nude woman can be seen as either a cog in the works or the eternal 'day dream,' exquisitely at odds with the man's focussed performance.

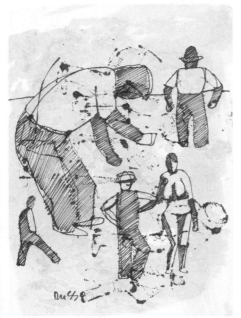

Figure 48

Over time Russo's social drawings have become increasingly metaphoric, with irony used as a frequent device to expose the absurdity in the 'real' and the 'real' in the absurdity. The figure loses texture, becoming almost entirely its costume. Yet Russo gets the effect of chiaroscuro by using the 'light' image to touch on a 'dark' theme. Thus, even the tone of a drawing will become deceptively artful. Through wit and humor, Russo will invite us to laugh at devastating portraits of human foolishness, at once foreign and familiar.

According to Russo, the most violent of his topical drawings happened during the Sixties when we were awash with cosmetic affectations that either covered up or subverted our 'flesh and blood' recognitions of man's inhumanity to man. In these drawings, we will see 'hard' nudes, who have become aggressive and predatory with armored breasts, helmeting hairdos, and advertisement-trained smiles. We will see a chorus line of Barbie Dolls, who are antiseptic clones in their sexual sterility, lacking nipples or pubic hair. Yet, what stops such drawings from becoming sour or dated is the humor, by which they cease reflecting a local

bias and imply the universal tendency to camouflage vulnerability.

Sometimes a drawing will have the completeness of a small parable, offering an absurd picture of modern civilization where everything is out of scale (Figure 57). The space has been divided into compartments, keying us instantly to the issue of limited perspective. There is an echo of Dada in the use of collage, where unrelated objects of symbolic connotations participate in an innocent high jinks. Thus, in the left hand segment, a garish show girl lifting her leg in a spirited kick is 'innocent' of the cannon, which parodies her gesture with its raised barrel and yet seems toy-like in its 'innocent' diminution. A poodle poses for the viewer, 'innocent' of its petite erection. Meanwhile we see the 'innocence' of nature as a removed reference point, barely present.

Furthermore, the players in this scene seem unaware of the adjoining panel, where we see a hierarchy of power symbols surrounding a proper business man, complete with three-piece suit, hat, and walking stick. Over his head, as a perverse stand-in for the Holy Ghost, is a graceless American eagle. In the background is a small but deadly war-ship under steam. Then, isolated in its own space is a disembodied medal, implying some mysterious code of honor.

On one level, we smile at the pointed comedy of this drawing, which is almost a caricature or cartoon. Yet, at the deeper level, the blindness of performers emersed in their own show is a jarring reminder that significant issues like aggressive violence can be either neutralized through entertainment or camouflaged out of recognition, becoming an ostensible 'business as usual.'

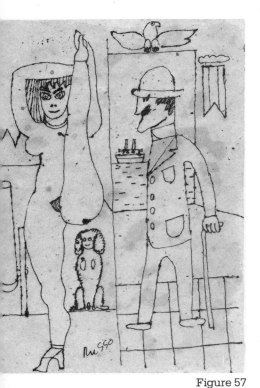

Figure 57

IN RECENT drawings Russo has developed his own iconography in that certain images will recurr from drawing to drawing, acquiring an accumulated set of associations. Significantly, Russo did not just decide to invest certain objects with symbolic meaning. Rather, he became interested in these objects because the culture has dignified them with meaning. Examples would be the hat, the umbrella, and the shoe. To Russo, the character of these objects can become very personal and human. If these objects can become us, however, then we must wonder about the reverse implication where we become them.

As an artist, Russo is interested in just this kind of impersonation. "To me, man as an actor, man as a mannequin, man as just a shadow…to me, those aspects are an important part of the nature of man," Russo has stated. "Too often images of style are interpreted in the context of history, but I think they are much better interpreted in the context of their own time.

"The hat, for example, became associated with male authority and has been seen as part of the male gesture, actually. Hats make a wonderful symbol, especially if I can liberate the hat from its traditional, descriptive literalness. You put two hats on one person or a man's hat on a woman, and all kinds of things happen that I find interesting. After all, hats have been expressive of human nature, as are shoes.

"I am fascinated by the kind of shoes people wear and why they wear such big heavy heels and why their shoes have to make so much noise as they walk down the street. I think details like that are an important part of the gesture," Russo asserts.

"It's amazing the kind of talent people have in choosing the right hat or the right shoes to express the right kind of impression they'd like to convey. Yet maybe it's again a kind of irony that man is not as real as he seems to be, and some of the things that describe most of his concerns are not real at all," the artist speculates, not with a tone of disapproval, but with a tone of piqued curiosity.

In fact, Russo has named our dilemma as we respond to his drawings exploring the relationship between men and women. How are we to feel about nudes whose bodies are twisted into the high-fashion poses of mannequins? What are we to think about men who look doll-like, with truncated, jointed limbs, camouflaged by buttonless suits and hats worn at a jaunty angle? Certainly there's something wonderful in the delight people take at 'dressing up' and 'strutting their stuff.'

On the other hand, putting the questions another way, what has been lost when men and women become such sleek performers that they can be drawn entirely by lines with hard abstract wedges and scallops to signify body hair? Russo doesn't answer these questions. He merely brings them up, disguising their "heaviness" with a lightness of tone, reminiscent of Chaplin's poignant burlesque.

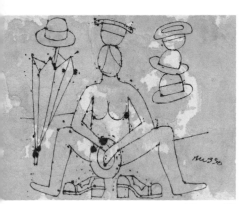

Figure 89

In one group of drawings, we will see a suited man with his nude companion, sunbathing under a boldly striped beach umbrella (to protect them from too much light). Either incongruous or redundant in this setting is a wardrobe of hats. Then, the irony is that these hats display great vitality — they are turned every which way, poised on their brims or upside down — while the couple maintains a static pose. A further irony is Russo's evocation in comic terms of a serious painting in western art: "Dejeuner sur l'Herbe" by Manet, where clothed men were offhandedly associated with worldly power while their women were nude to serve as erotic playmates.

Now, what does it mean when the woman begins to play with the male's power symbols (Figure 89)? Russo has several drawings where the nude will be literally hemmed in by masculine appointments (hats, umbrellas, walking sticks, heavy shoes). She will use the hat to hide her genitals, but she will also juggle the hats. She'll balance hats on her head. While the actual male seems to be missing, she'll flirt with his masculine possibility. In fact, these totem objects soon have so much gender that Russo can do drawings exclusively of hats or shoes, and a certain kind of sexuality is implied.

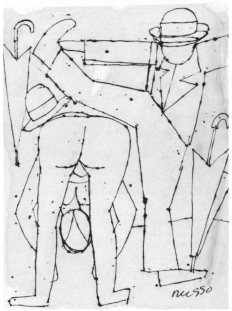

Figure 98

Yet how are we to respond to sexuality that has no sensual or animal association? In Figure 98, a suited man has raised his leg above a woman who bends over, her back to us, peering at the viewer through the clefts between breasts and buttocks. Humorous and clowny, yes, but there is also a freedom implied in her ability to mock her body without losing it. Is such irreverence a good sign or a bad sign? By the same ambiguous token, we can feel sympathy or contempt for men jeopardized by impossible headstands in order to balance their hats, or for men in danger of losing their heads as they pose in "group shots" with camera-ready grins. We'll have mixed feelings about svelte nudes, more matte surface than energy, as they gather ceremonially around a super-large, high-heeled shoe.

By implication, these figures can seem like actors in a comedy of manners that parodies our own civilization. When these figures show off, do tricks, and risk pratfalls, nothing tragic seems to happen, and is that in itself a tragedy? Even when the figure breaks into pieces — the isolated torsos, arms, legs, and breasts seeming as impersonal as underwear designs or catalog items — this fragmentation is a far cry from violent dismemberment. The point is that Russo's tone itself becomes a mask. Should we see his insistence on humor as heroic, an enlightened means of transcendence by which we survive our roles as performers? Or should we mourn the missing heroic, conveyed by the absence of sensuality, vulnerability, anxiety, or any energy of a searching nature? It's as if, the more doubts we have about the nature of the figure, the more invested we become in its significance.

In this regard, ambiguity both complicates and deepens our response. Or, as Russo explains: "In my kind of work, the more ambiguous the position of the figure, the more powerful this position becomes, and also the more critical this position becomes. My politics is just that: to explore the relationship of the figure (the individual) to the social condition, to the state, to all the historical factors, and how they effect the individual."

In this regard, Russo's 'innocent' drawings are profoundly sophisticated. He has countered the 'lightness' of contemporary imagery (via fashions, styles, postures, games) by the shadow of historical perspective. Then, consider his wit to deliberately evoke echoes of puppetry, burlesque, snapshot portraiture, fashion shows, and clothing catalogs. These are not conventions Russo has invented. They are traditions created by the culture to express itself. They are forms of street theater by which we ordinary people come to a concensus regarding morals, manners, social relationships, values, and higher ideals like "Truth" and "Beauty."

"Artifice is the highest form of sincerity in the artist," the French writer Colette observed. This kind of sincerity infuses Russo's drawings when seen as a total statement regarding the figure as itself: wonderfully limber, articulate, sensitive, emotional and enduring: wonderfully awkward, tongue-tied, conflicted, and fragile. In fact, the one word Russo has used to describe all his figures (and there are thousands) is "refugee."

Thus, when Russo uses chiaroscuro, when he explores the tension between light and shadow, energy and form, the rational and the absurd, he makes a case for wholeness not as a static state but as an ongoing scramble, where the figure is always "fresh" and therefore "foreign" to the footing of a given moment. To that extent, Russo maintains his own "innocence," which has to do with tolerant curiosity about a fugitive status which will surprise him, too, with its inexhaustible potential for change. As he explains: "Drawing itself is a struggle. Searching for shapes, the pen cuts and wanders. The pen can start in the most unlikely place in the world just to see what happens."

Jane Van Cleve,
Portland, Oregon, March, 1981

THE DRAWINGS:

"How Do You Experience Human Worth?"

I. Resources and Directions [1-21]

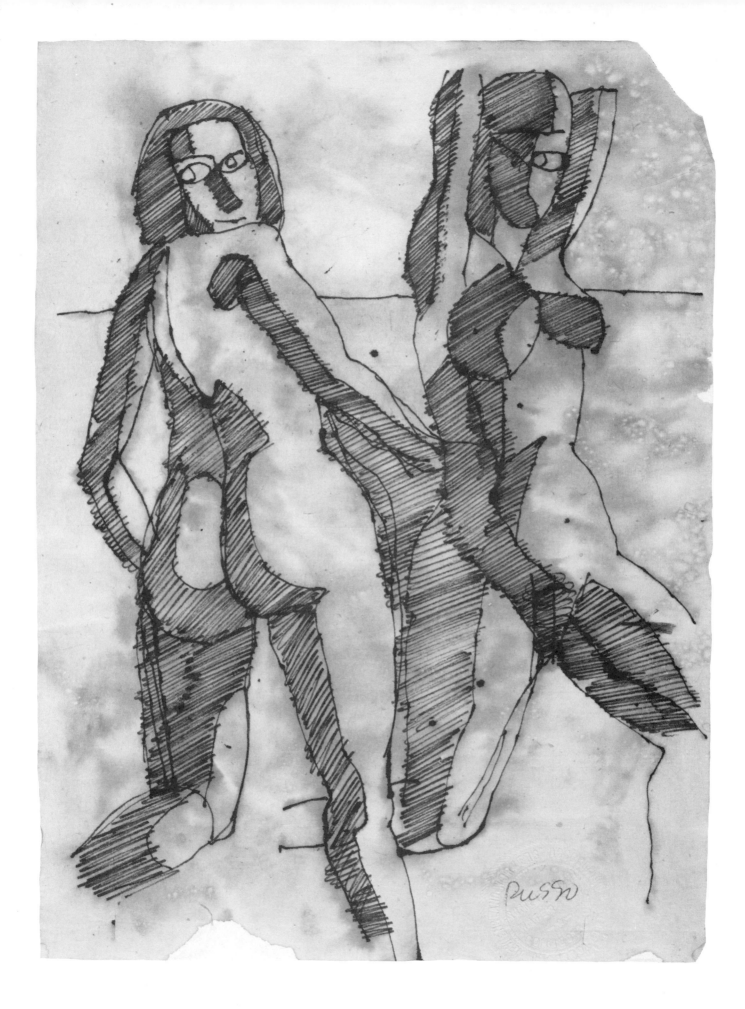

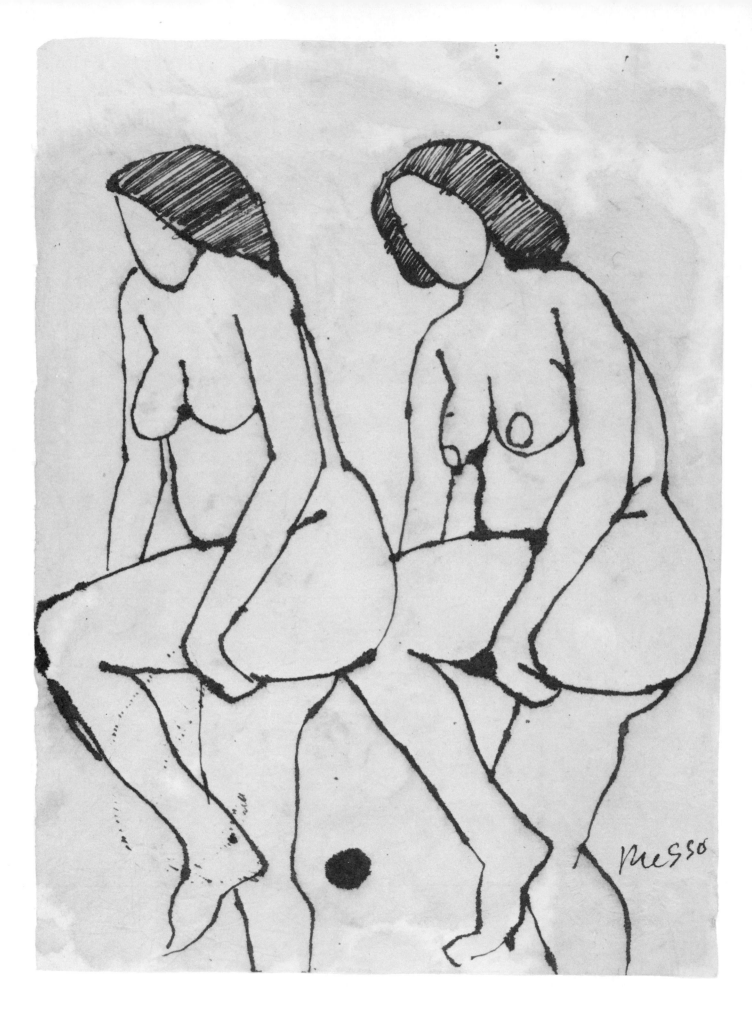

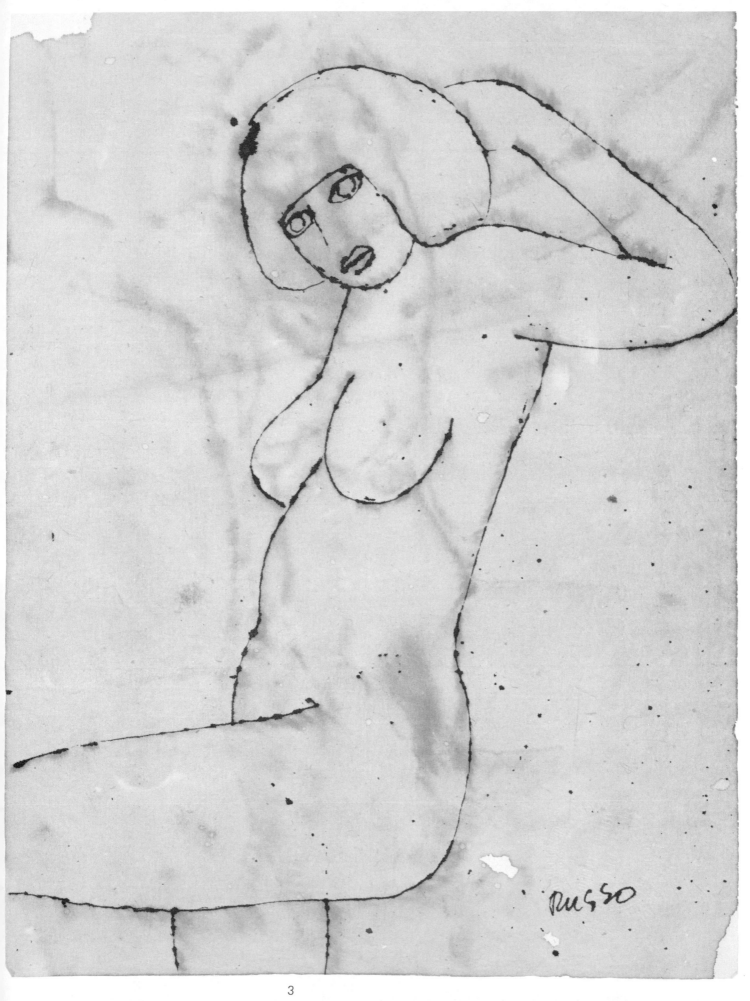

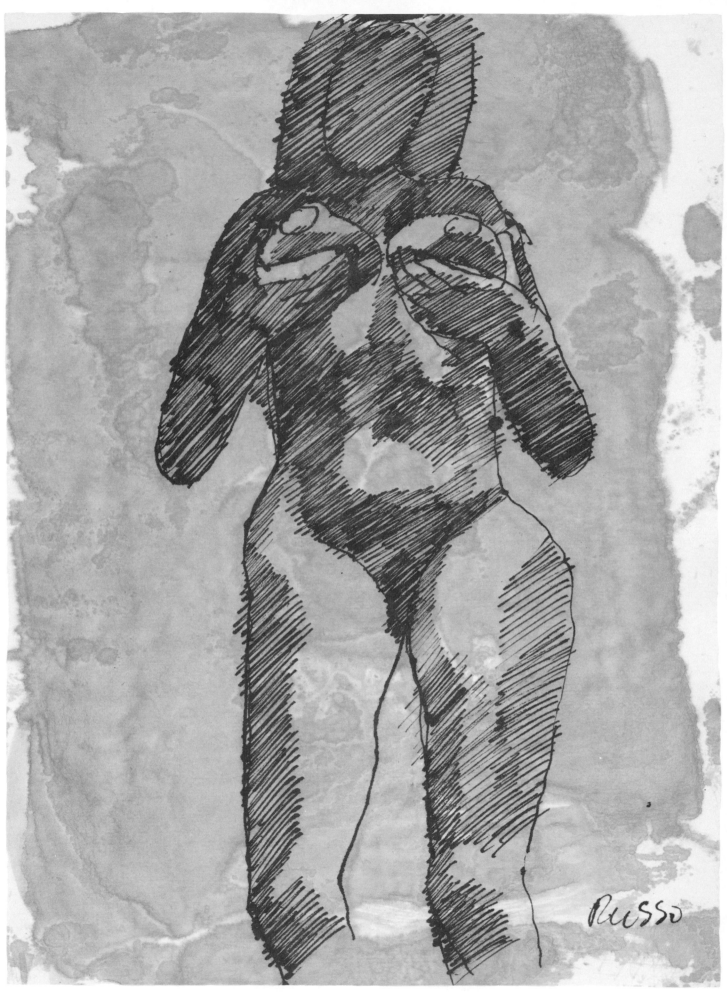

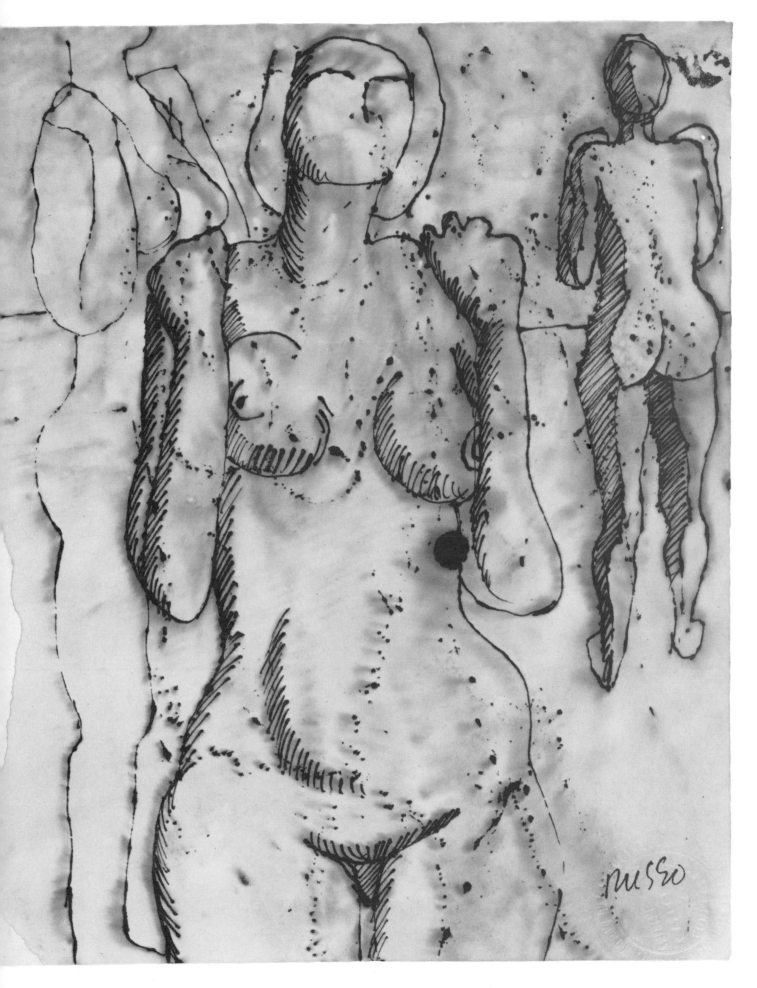

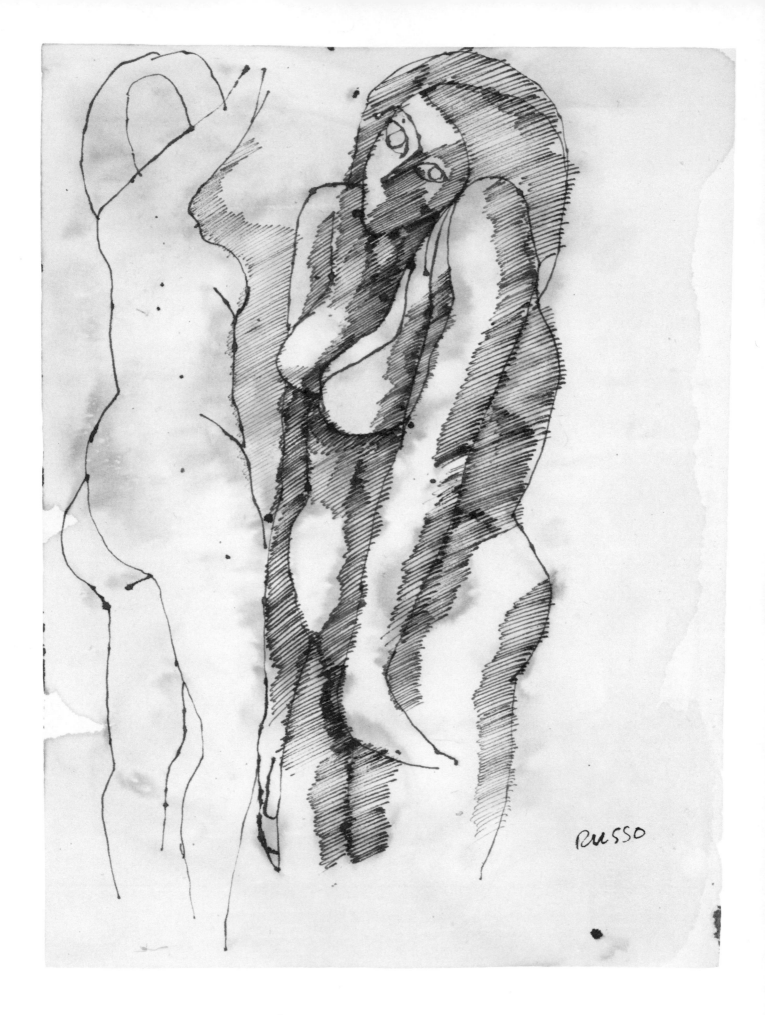

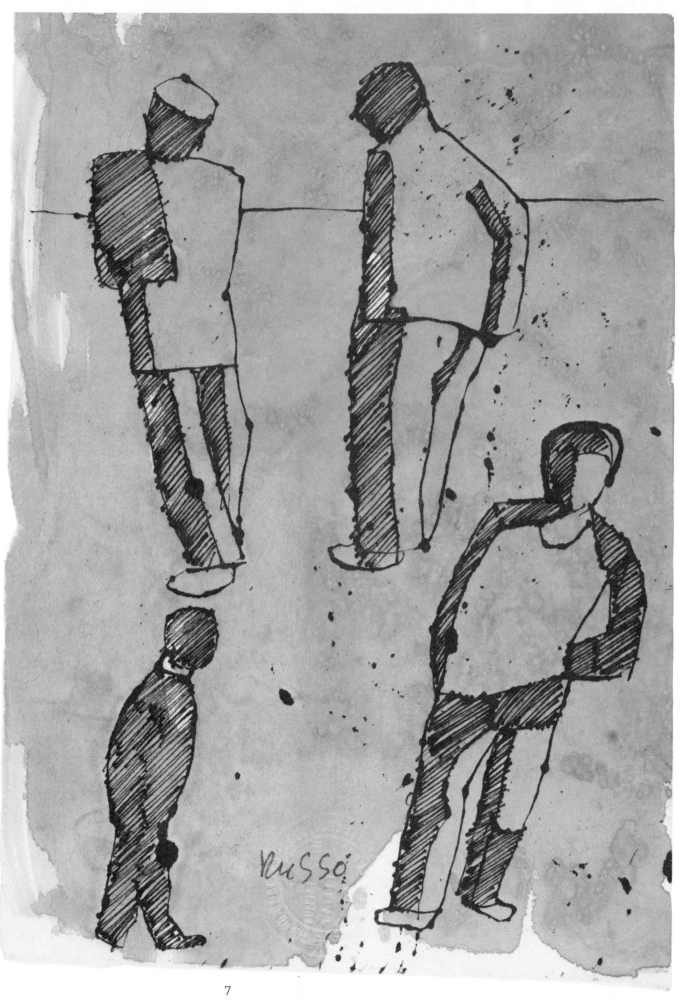

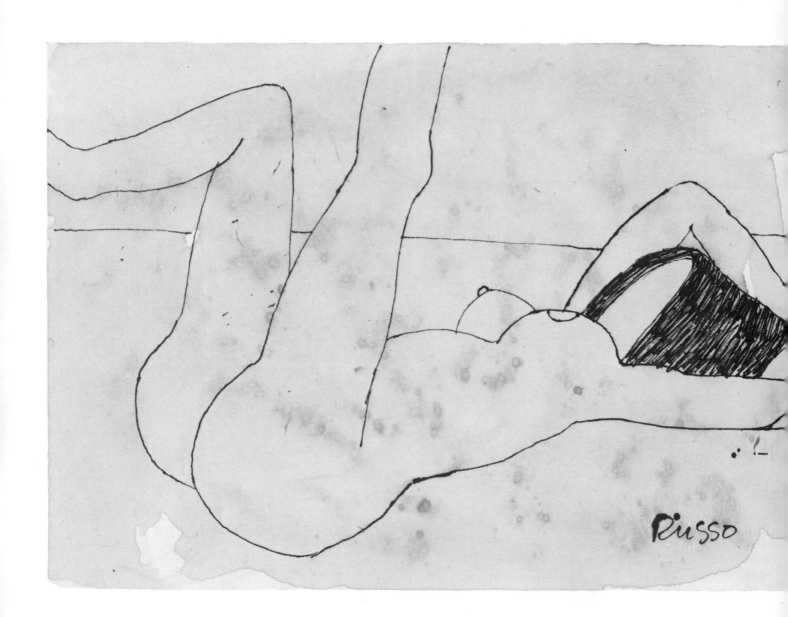

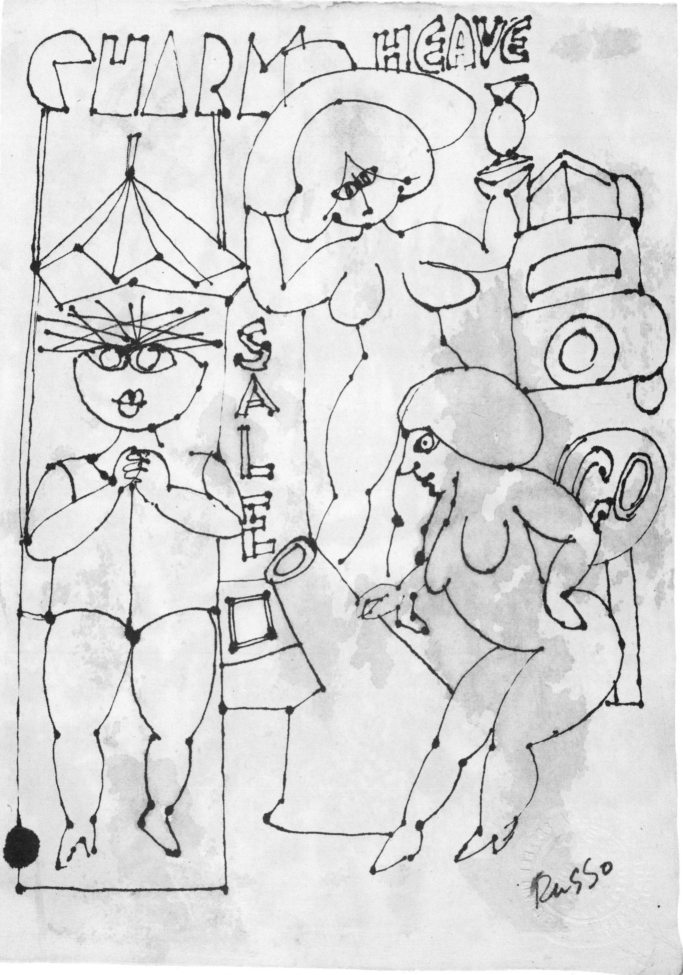

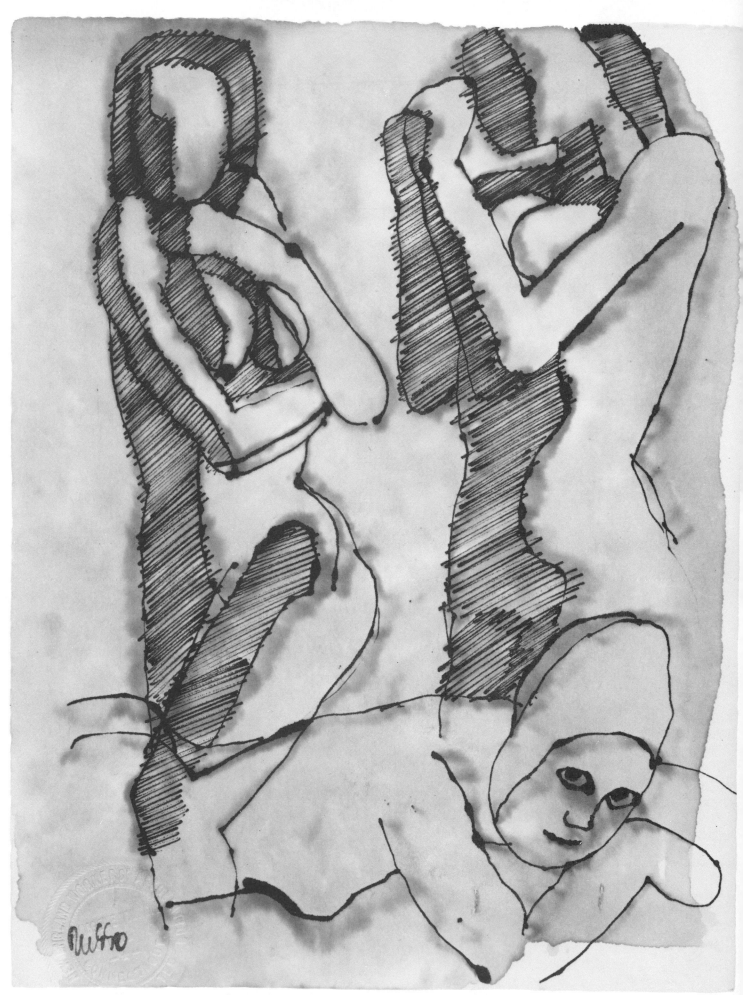

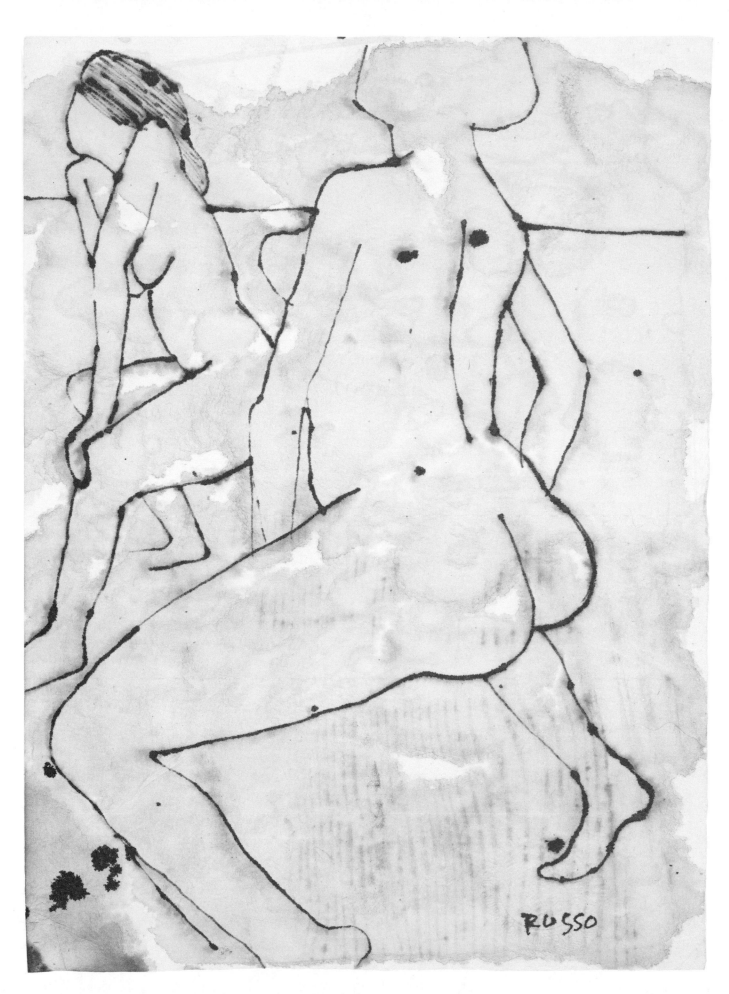

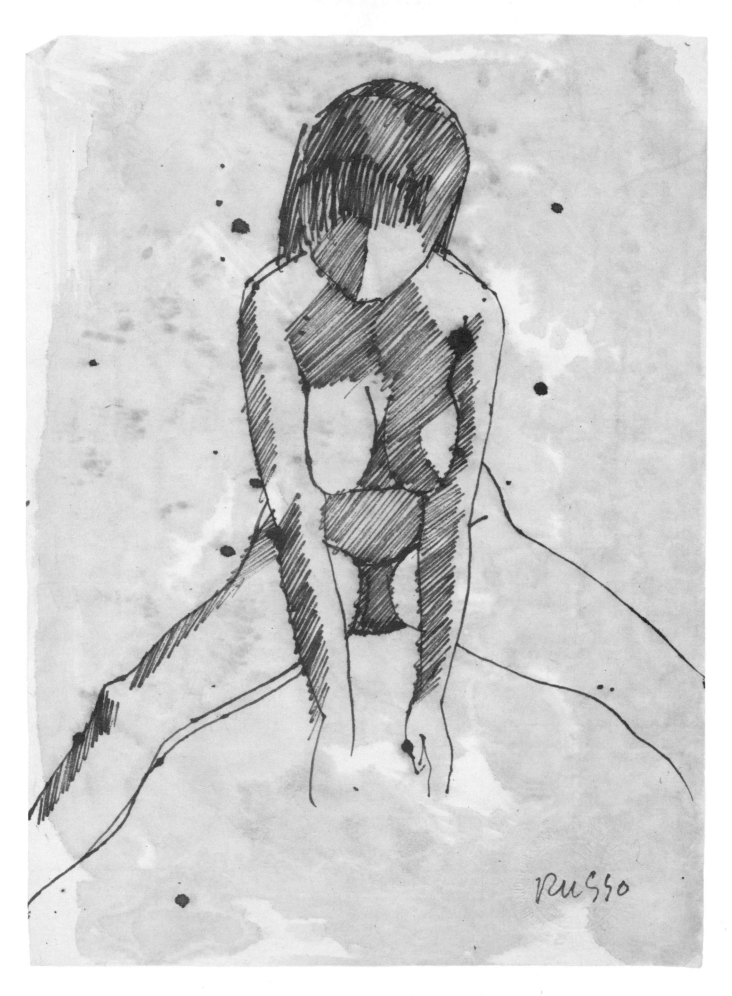

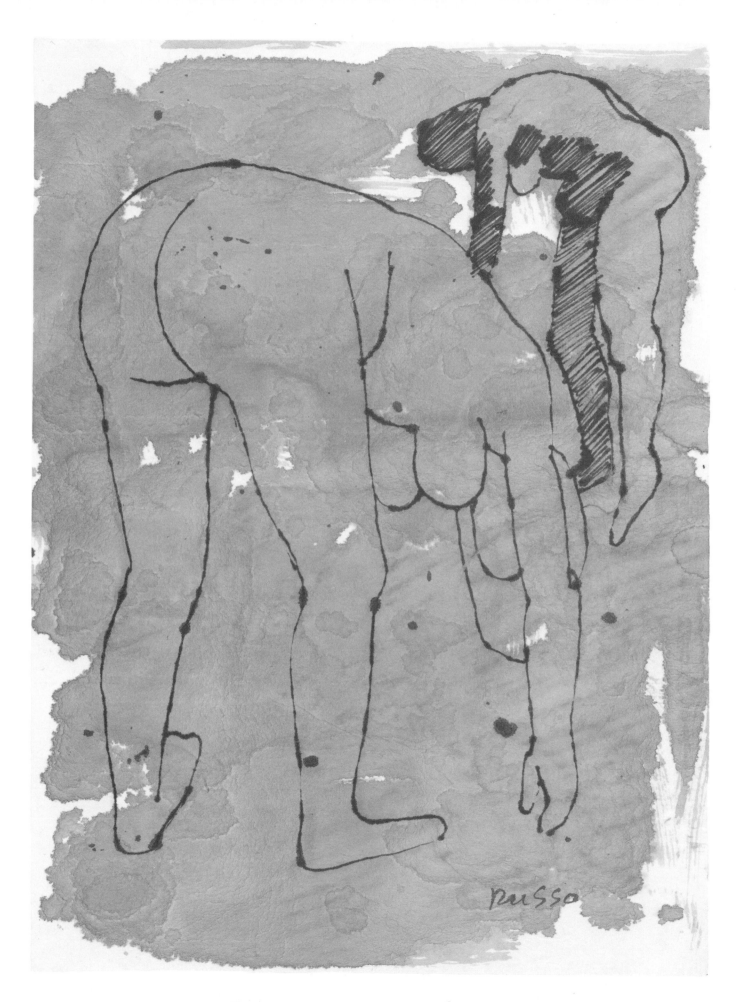

13

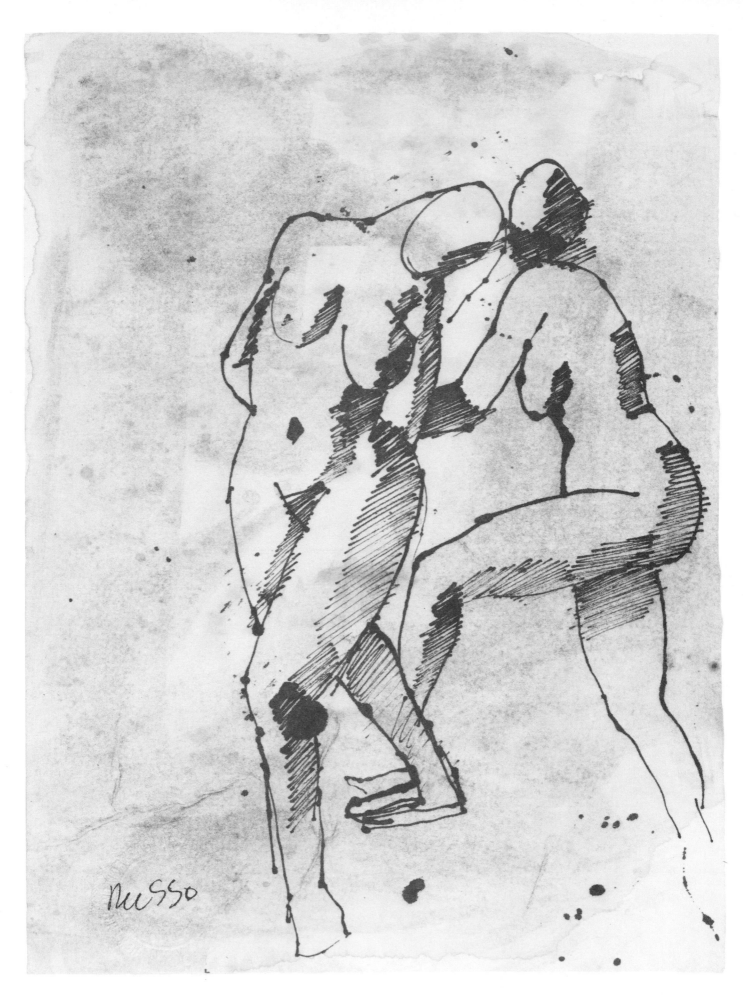

14

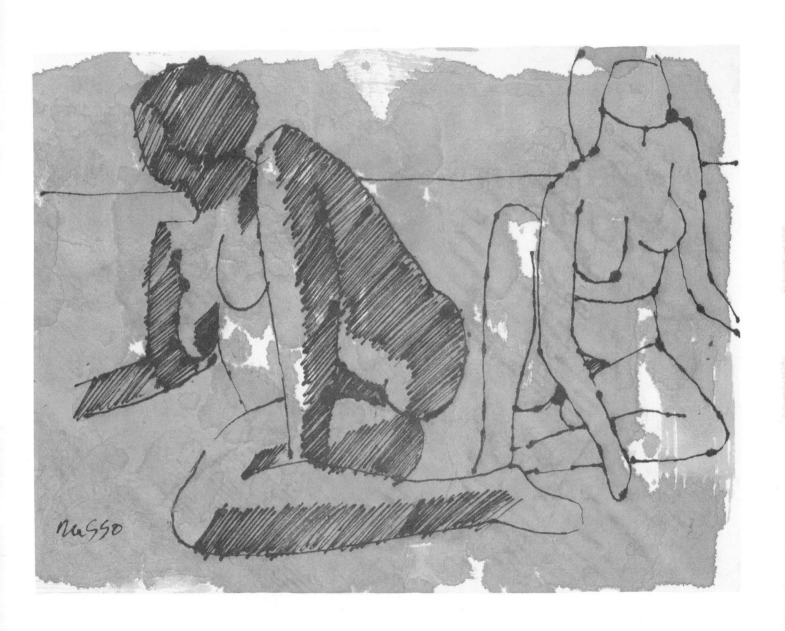

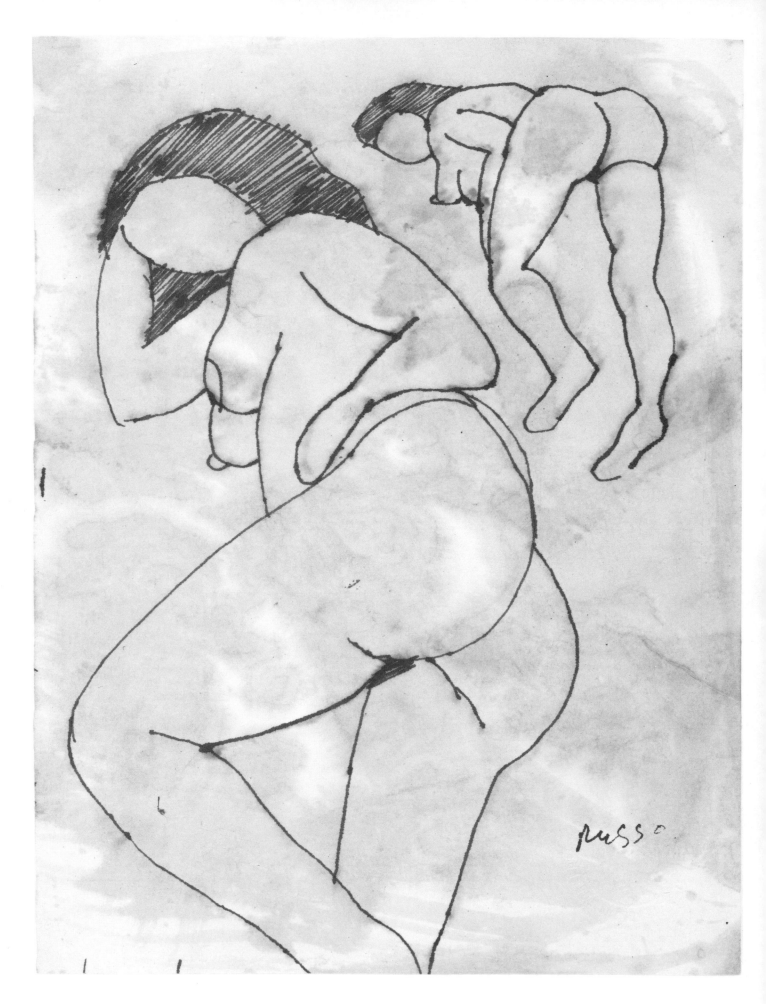

16

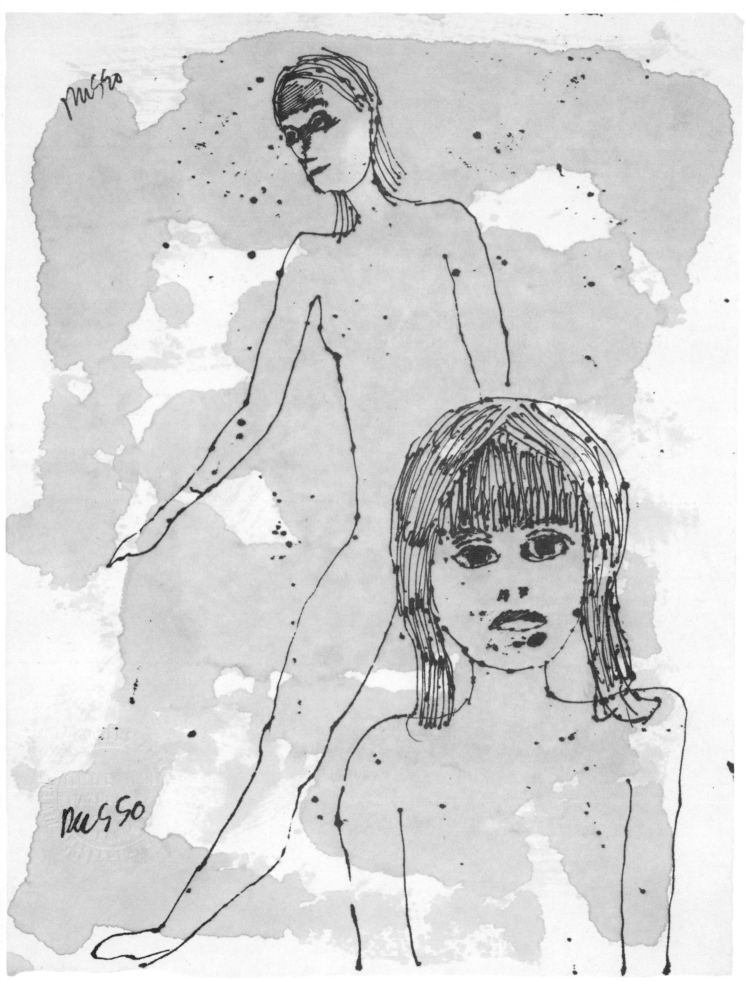

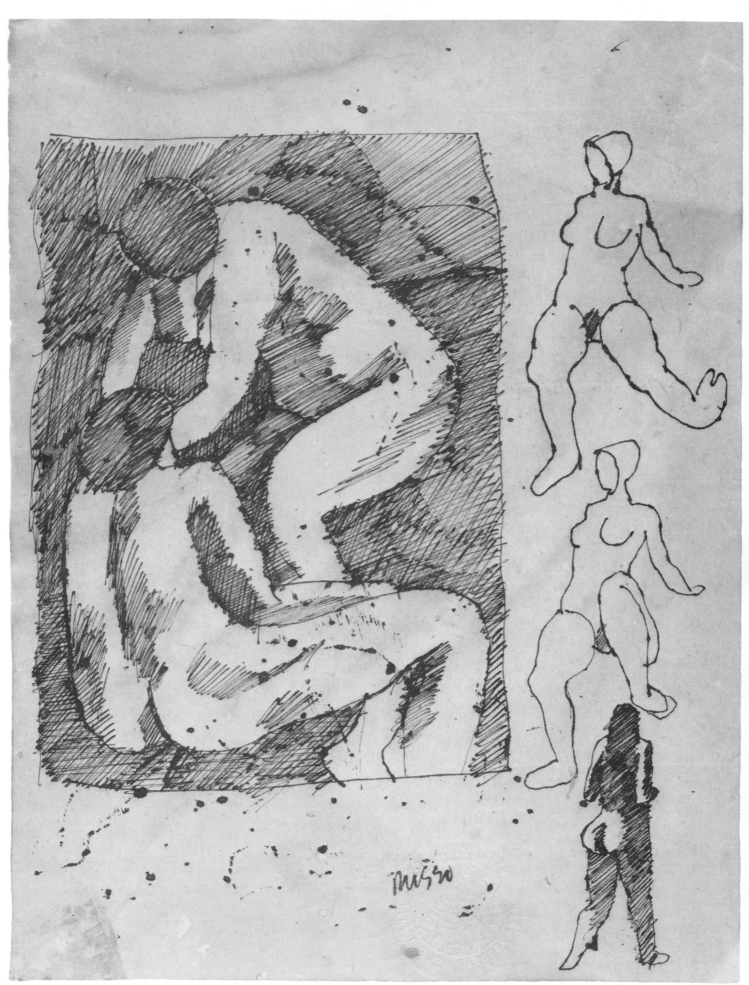

18

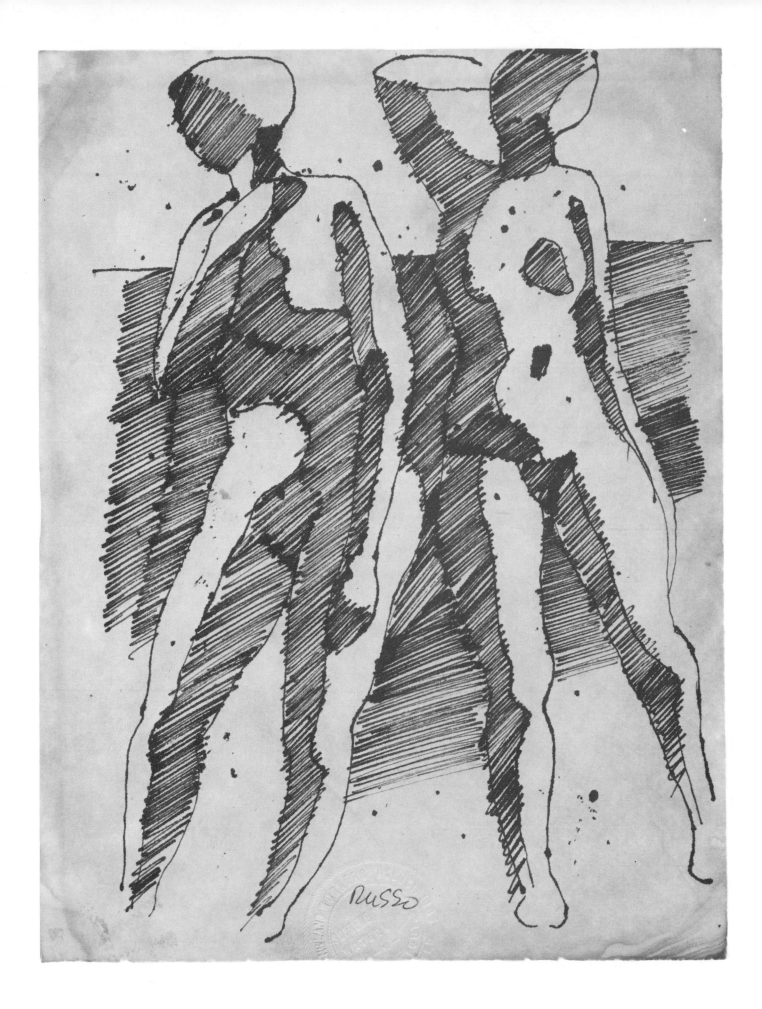

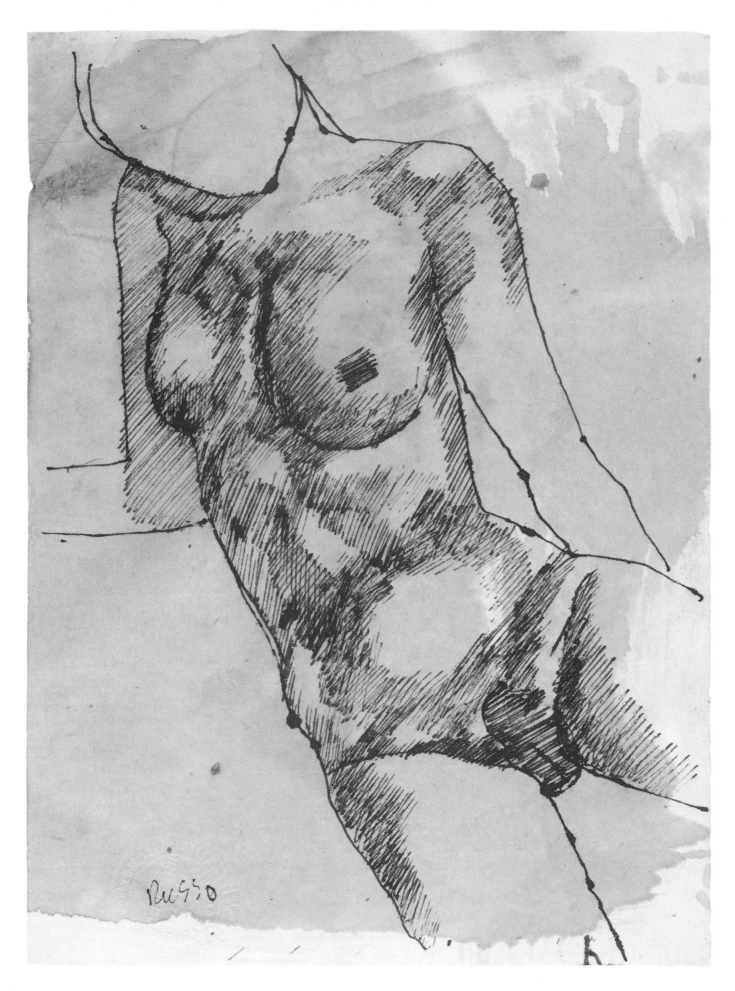

Russo

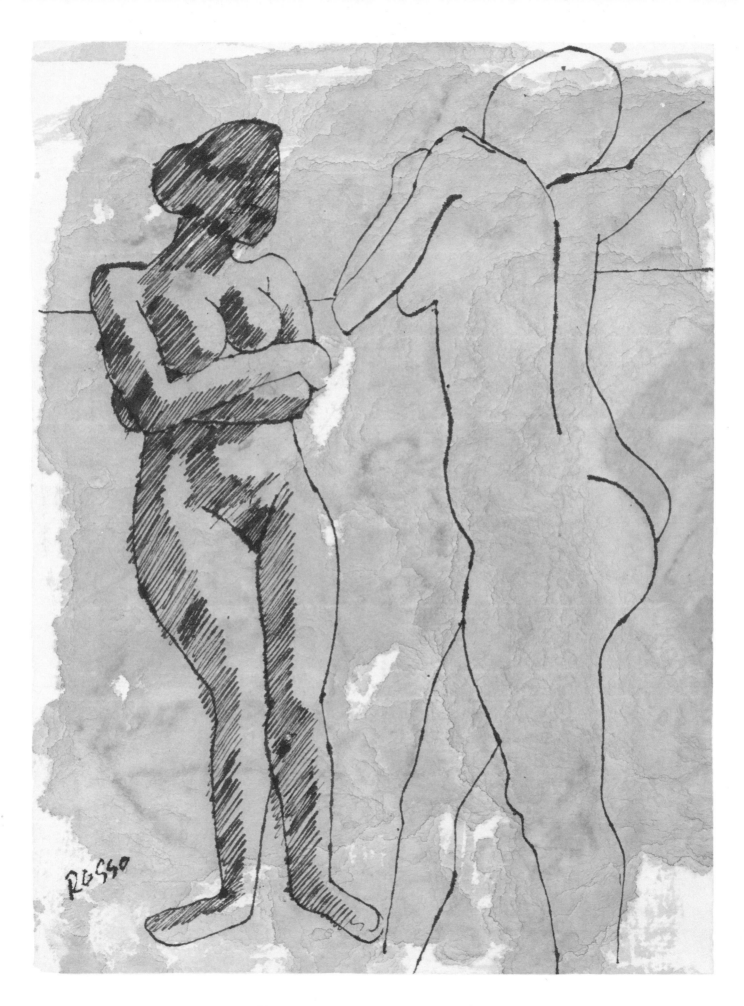

21

II. The Nullified but Defiant Image [22-36]

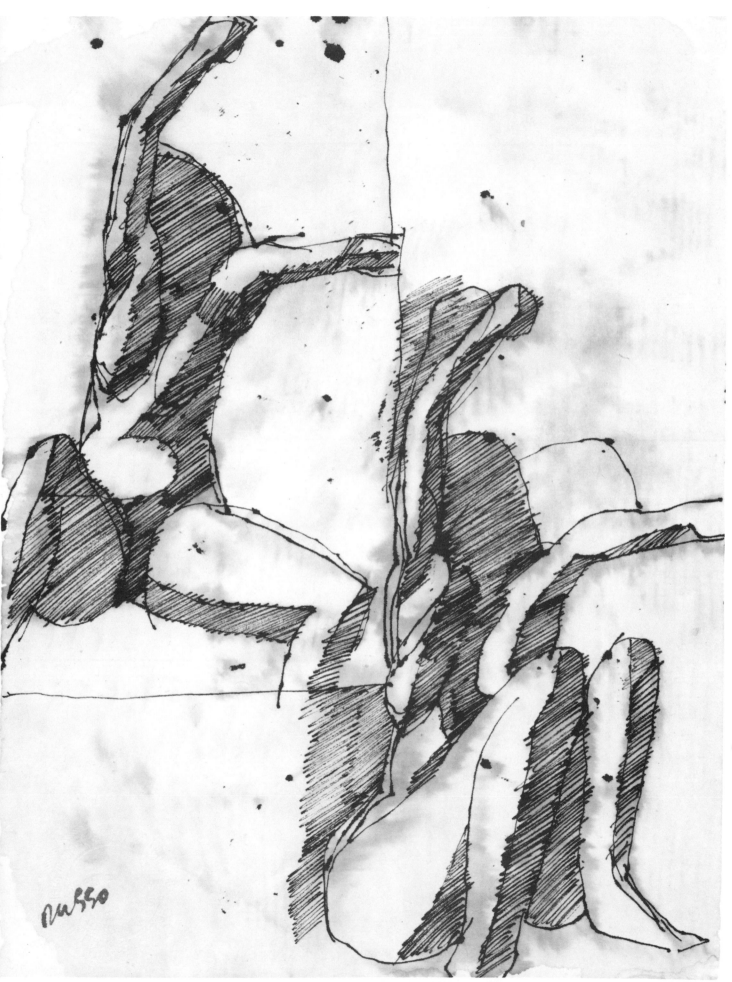

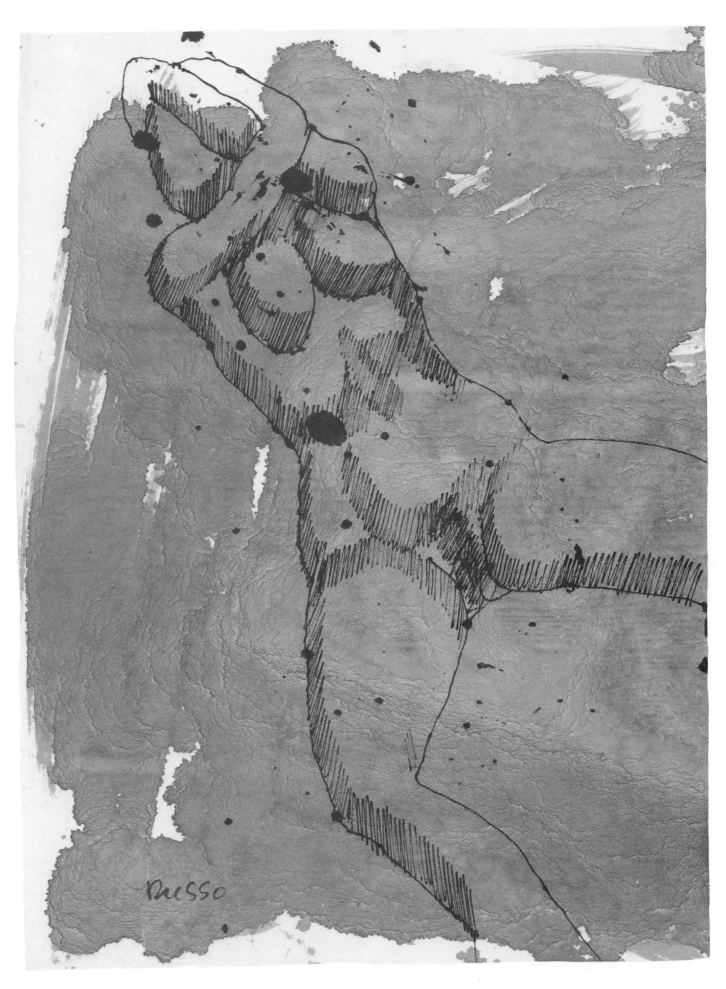

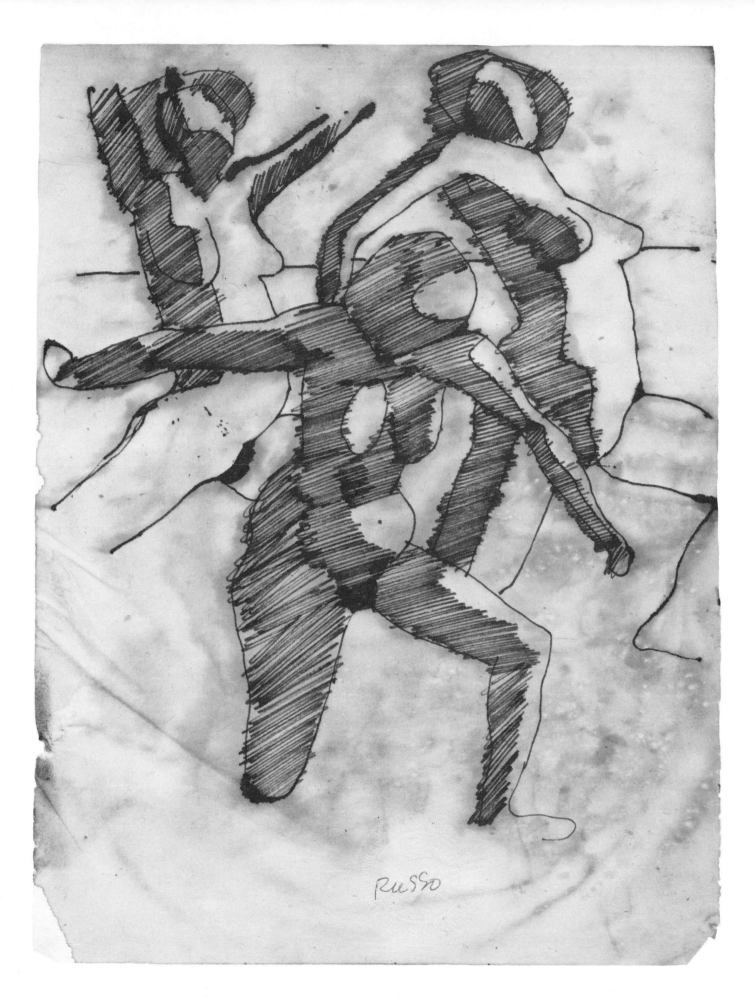

24

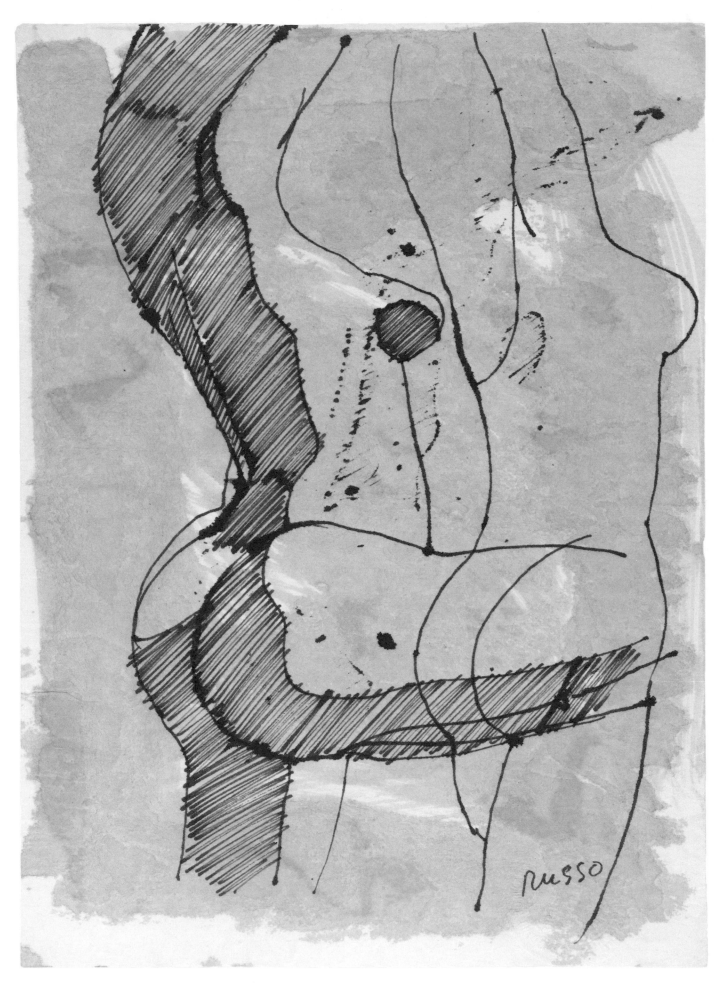

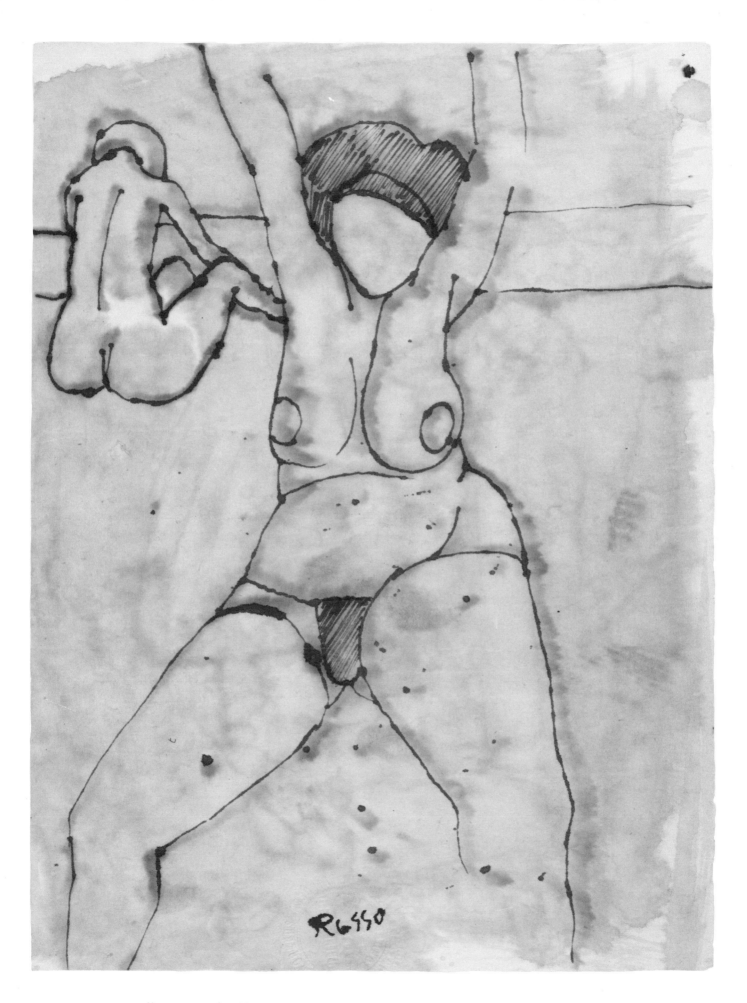

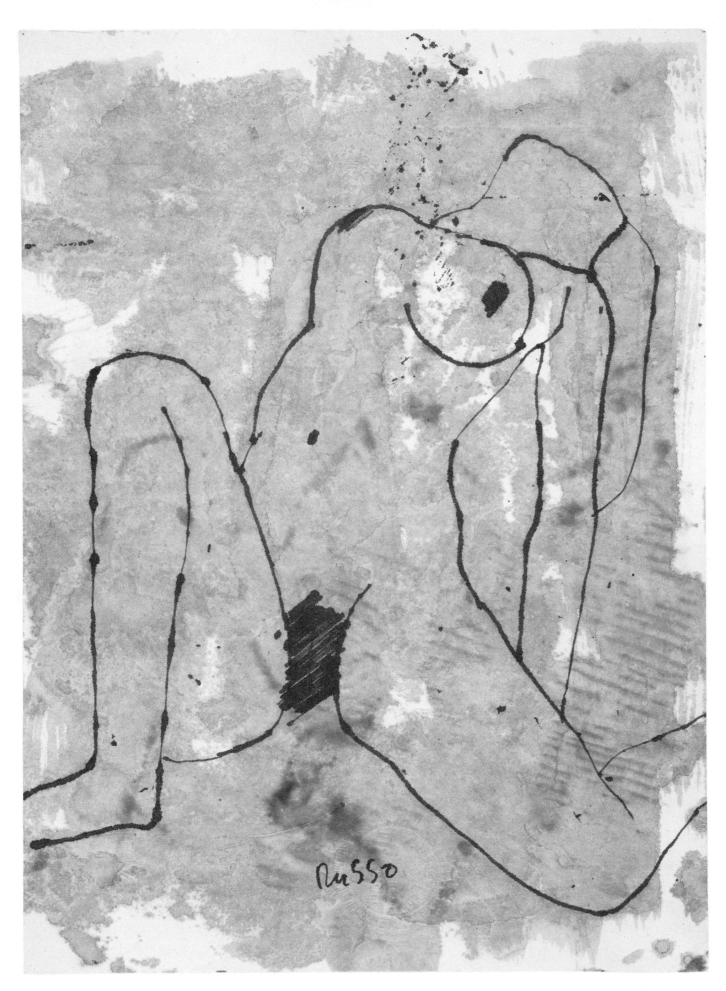

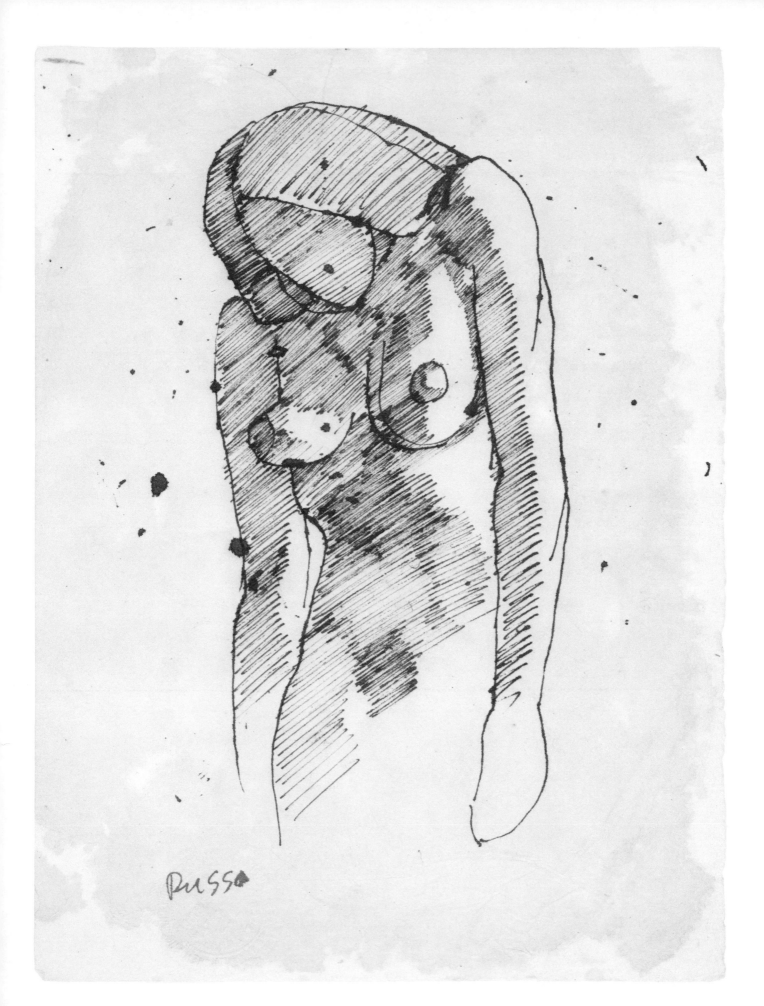

Russo

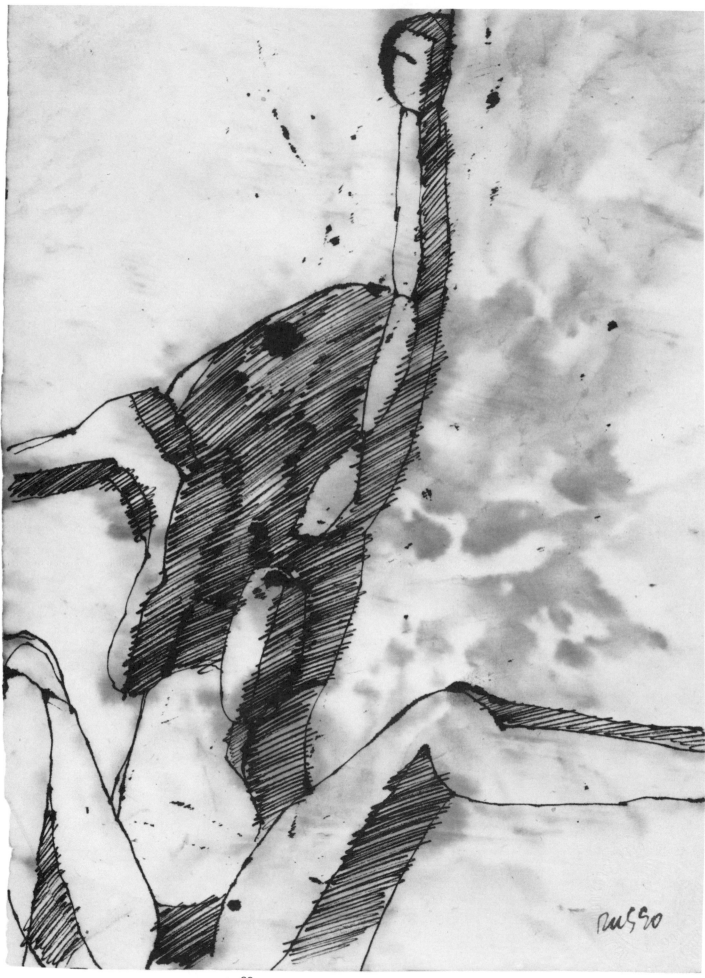

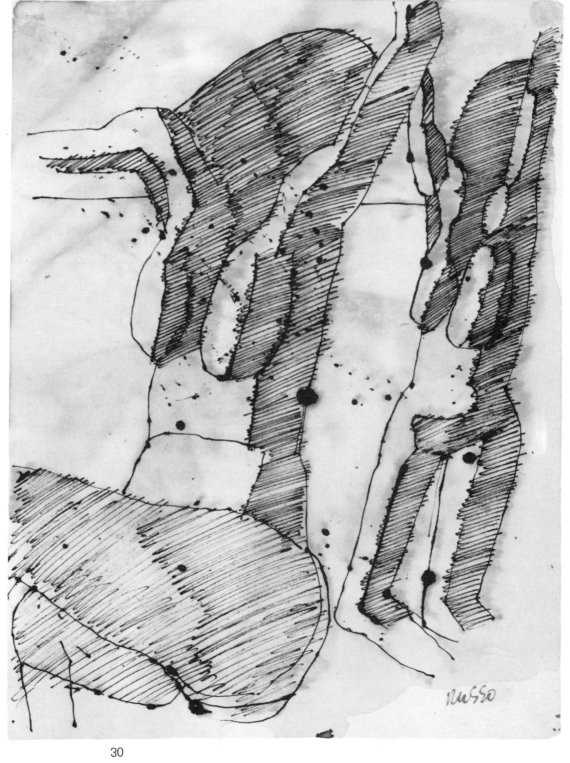

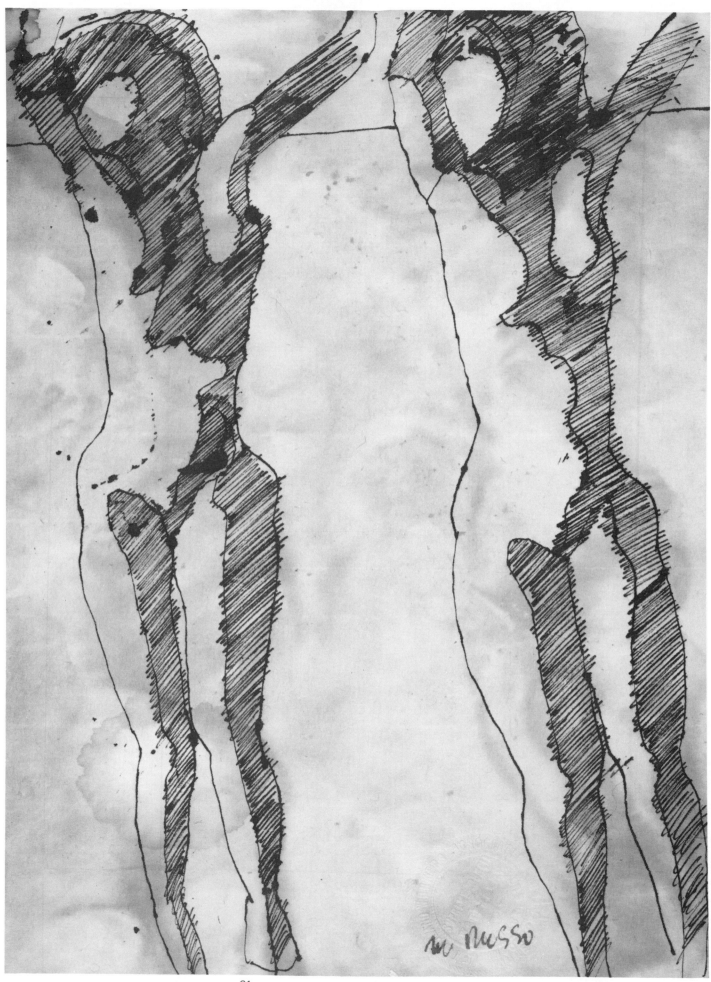

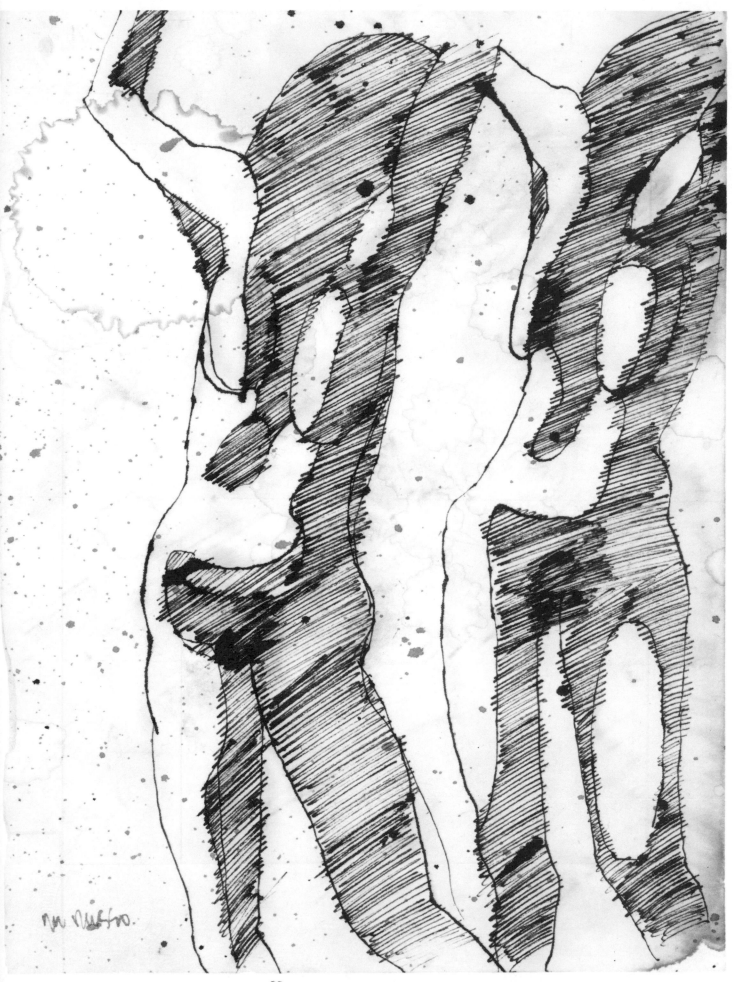

32

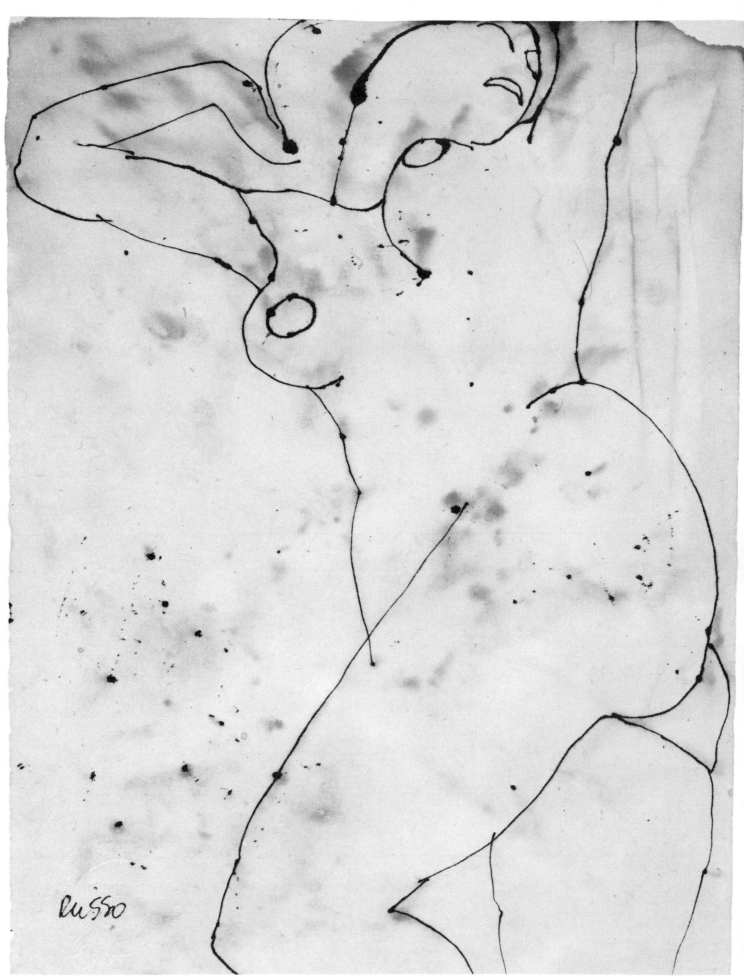

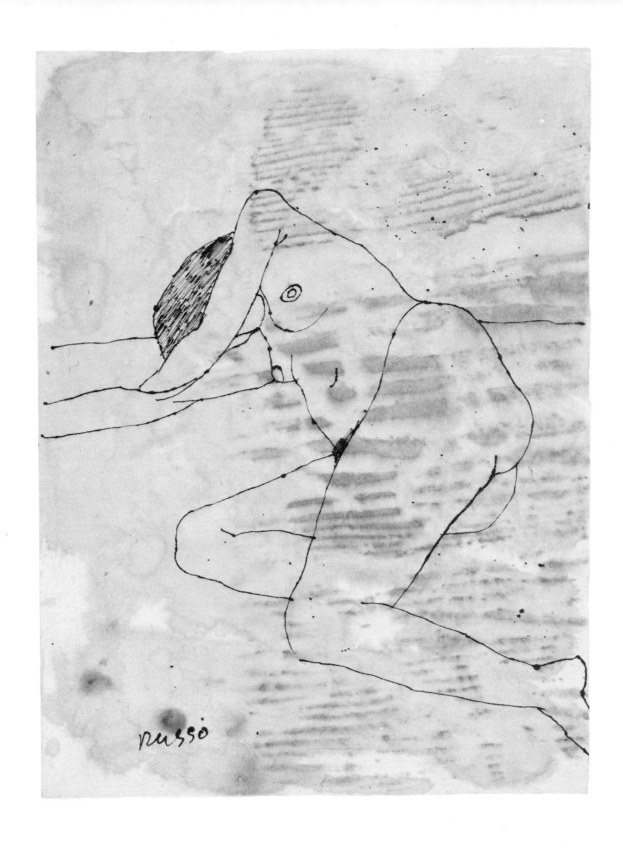

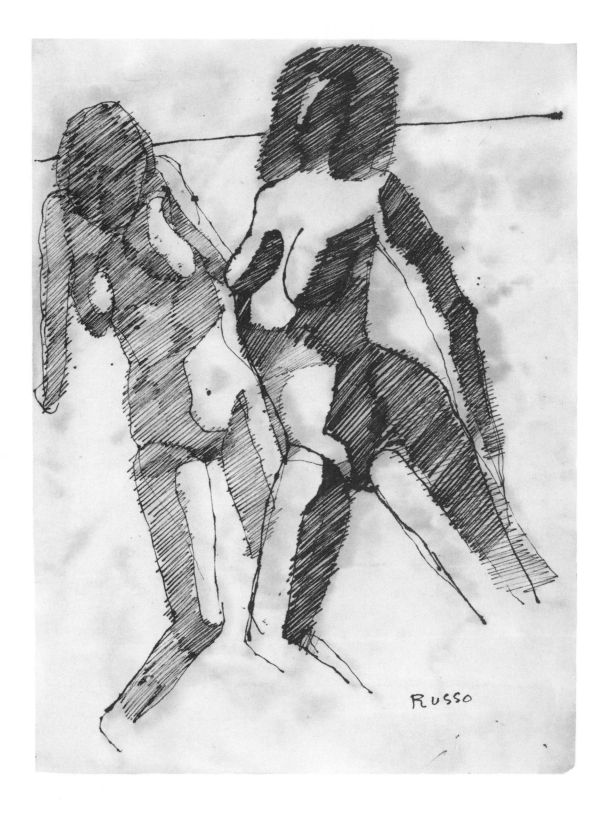

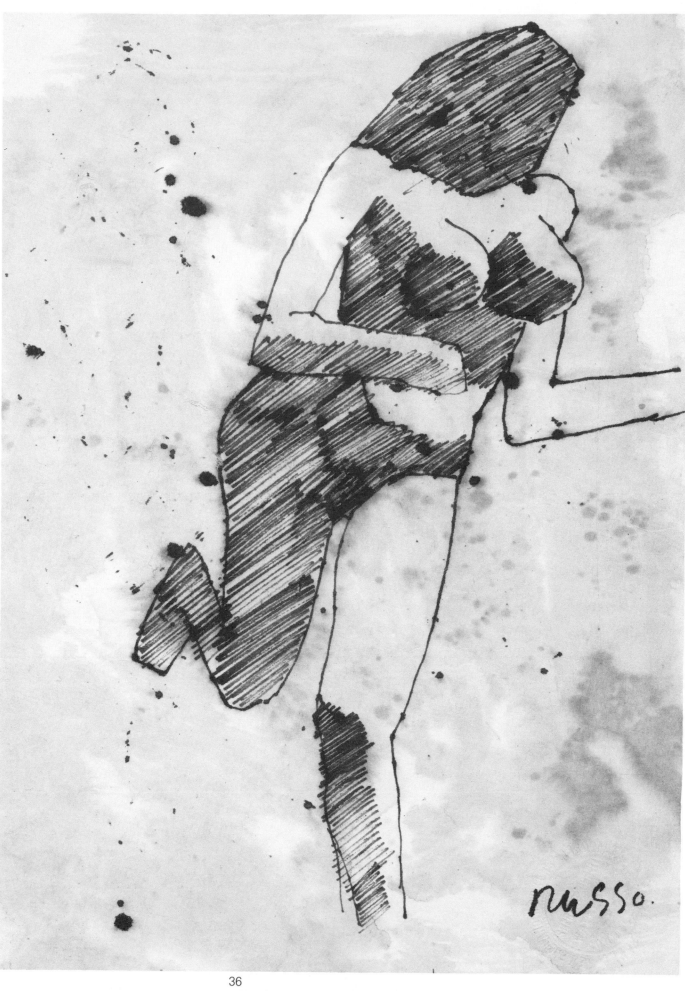

III. Our Undiminished Existence [37-53]

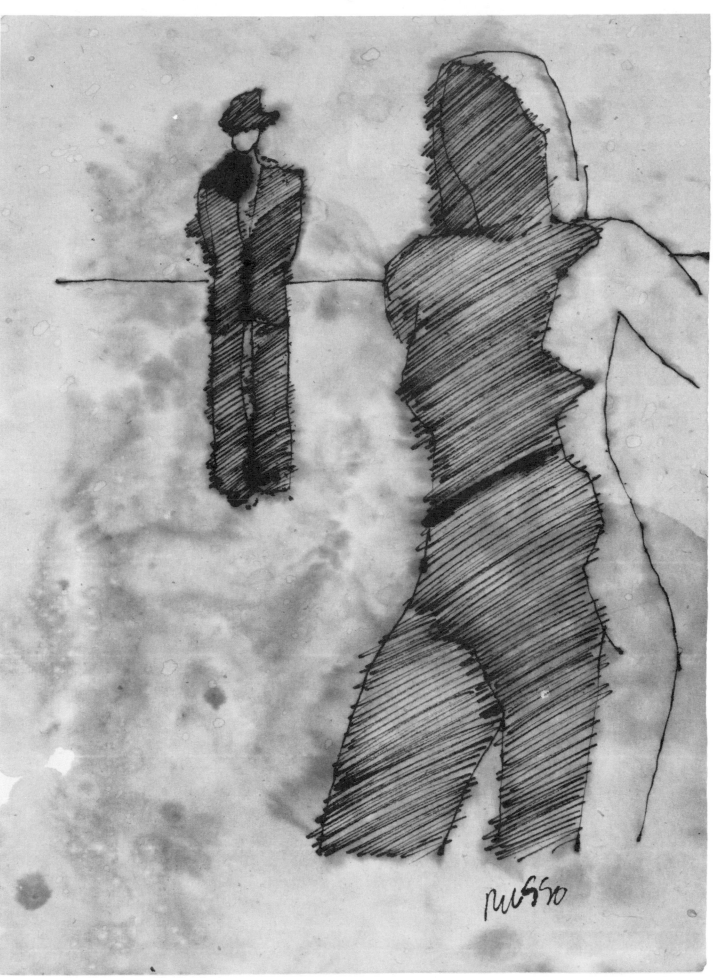

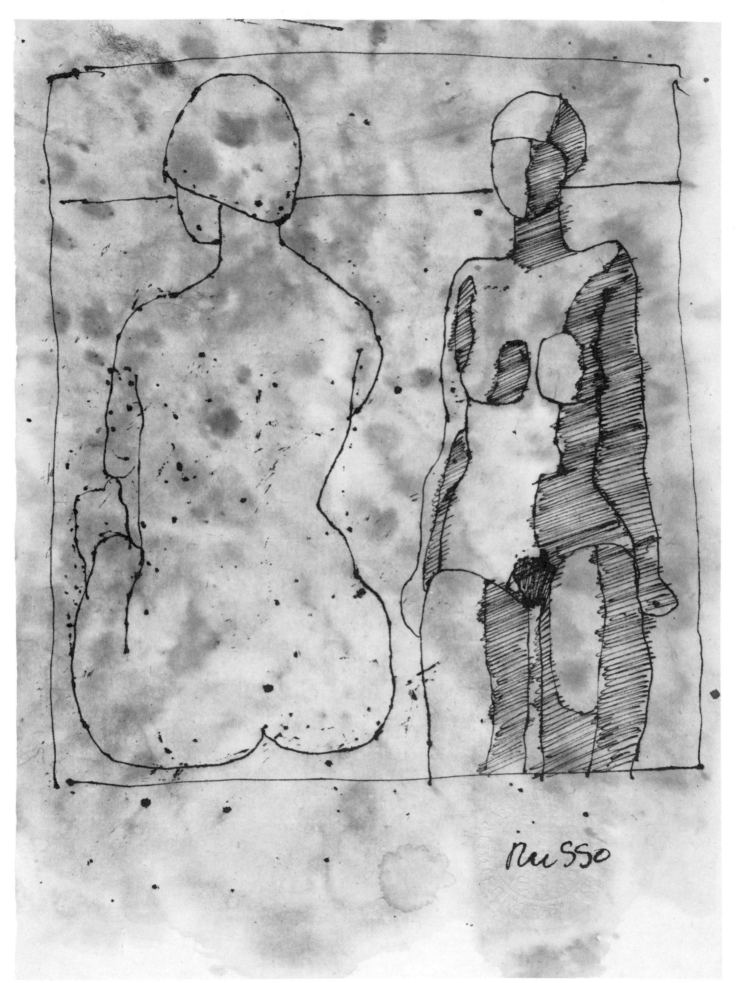

Russo

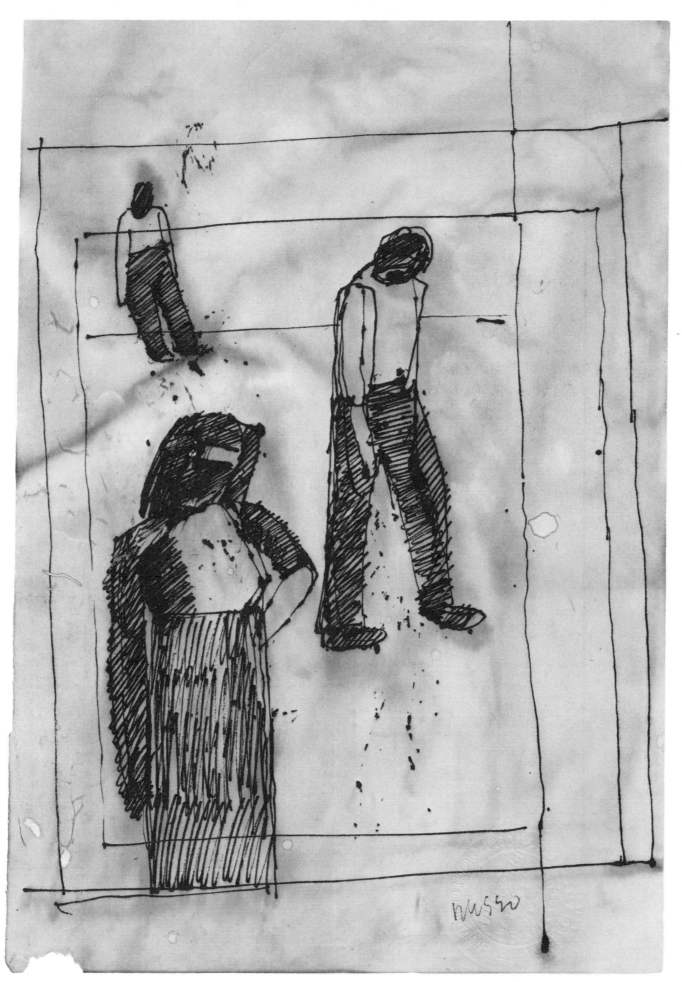

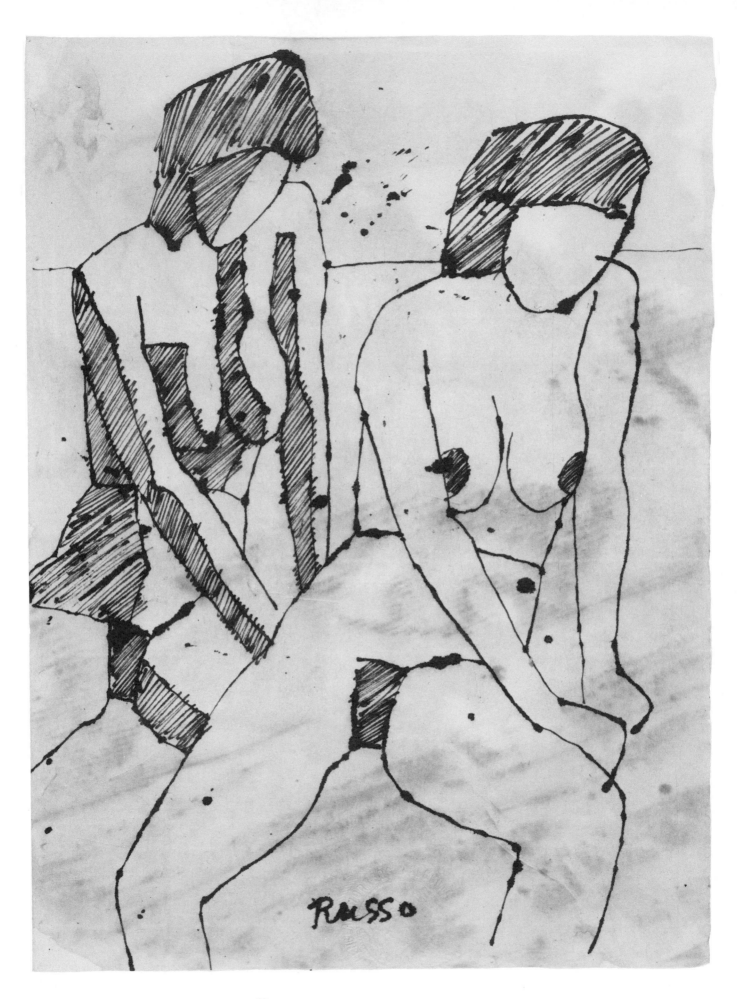

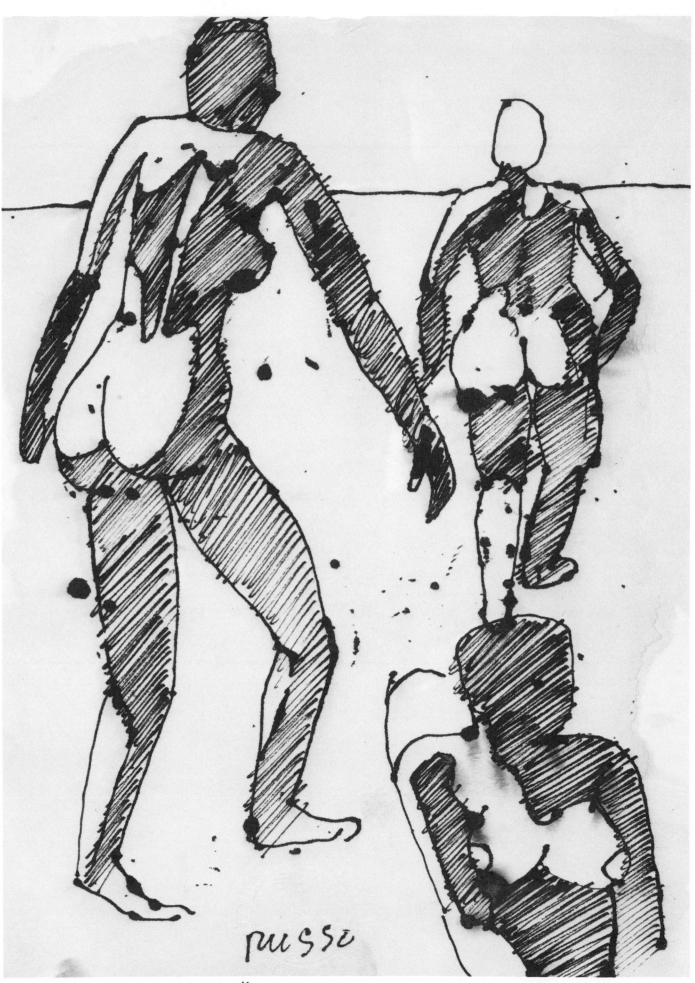

pusse

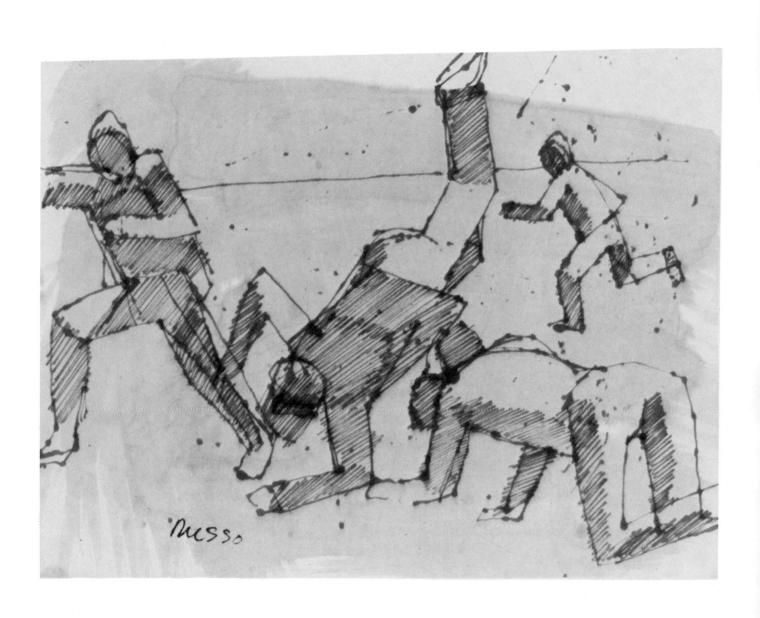

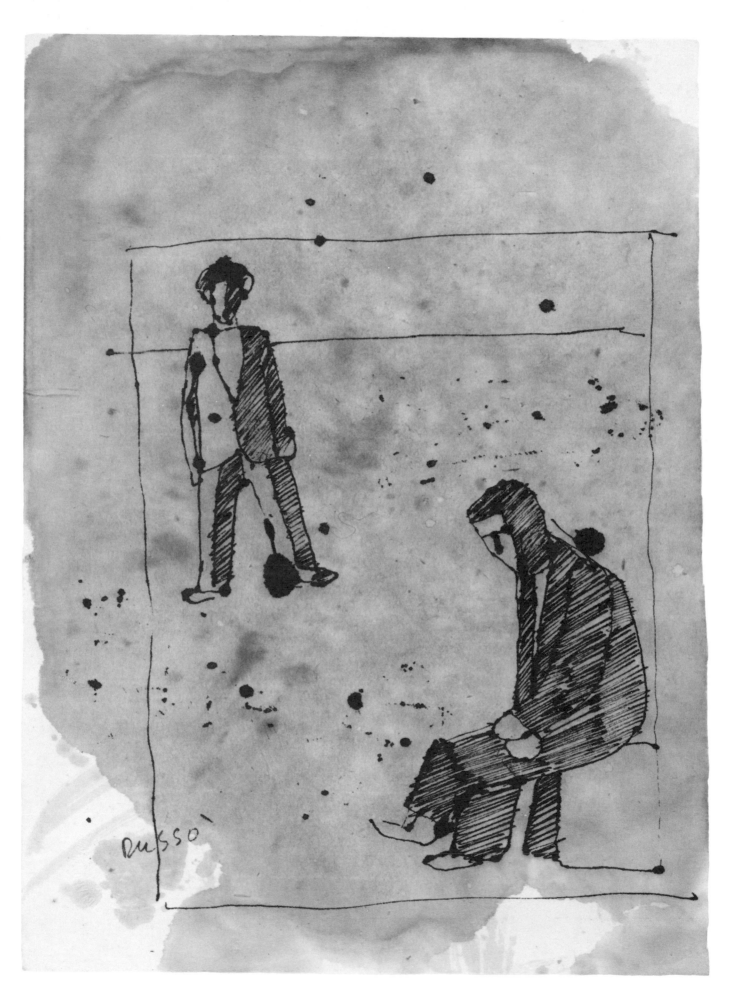

43

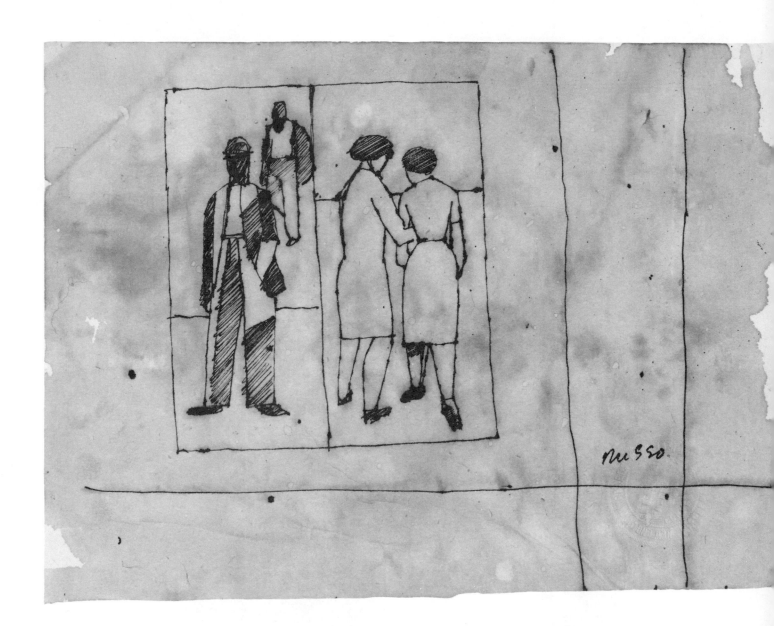

44

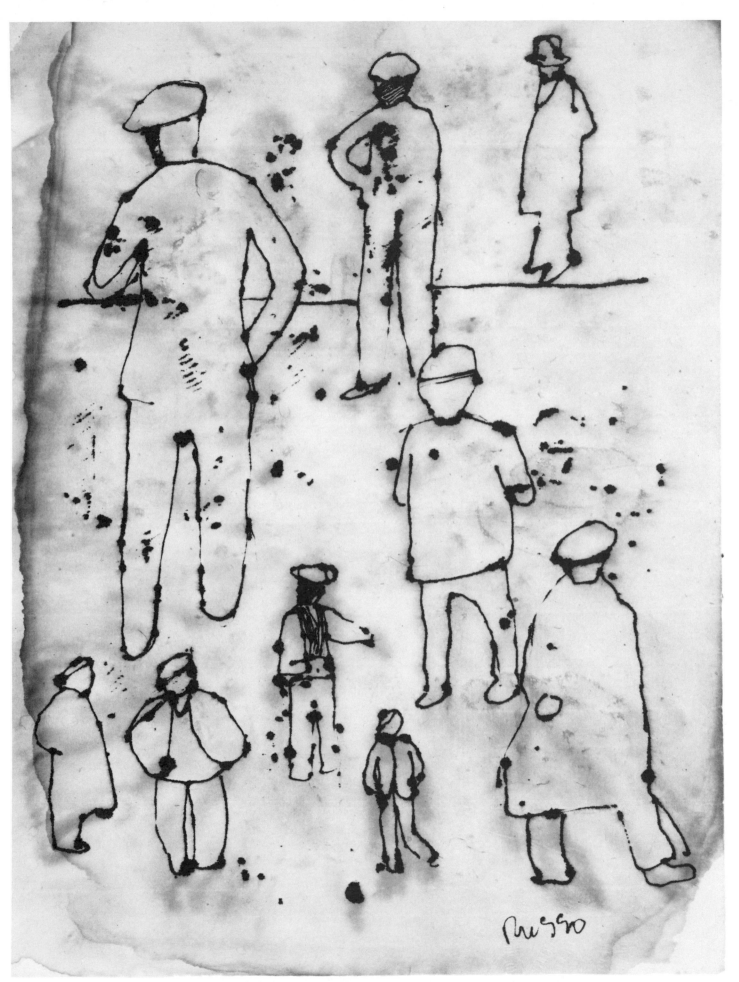

45

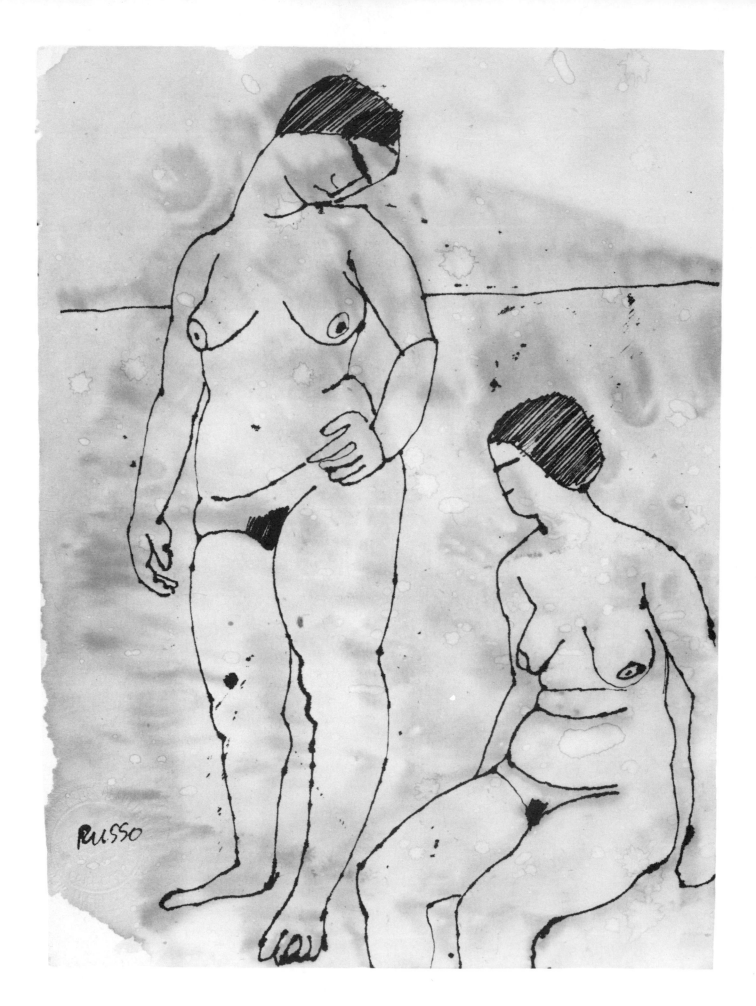

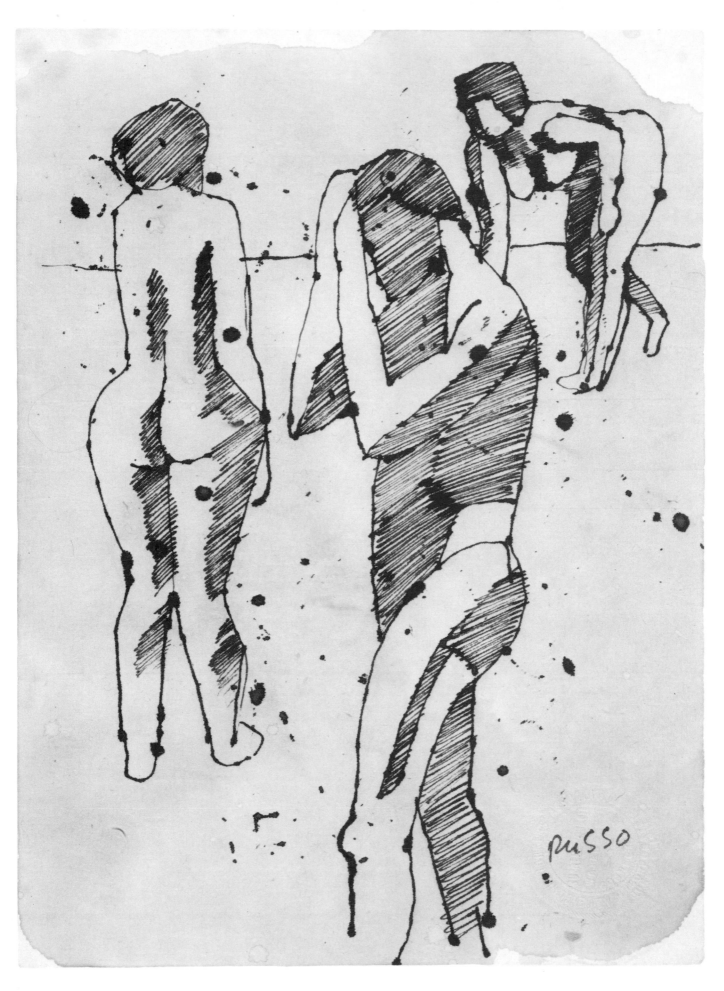

47

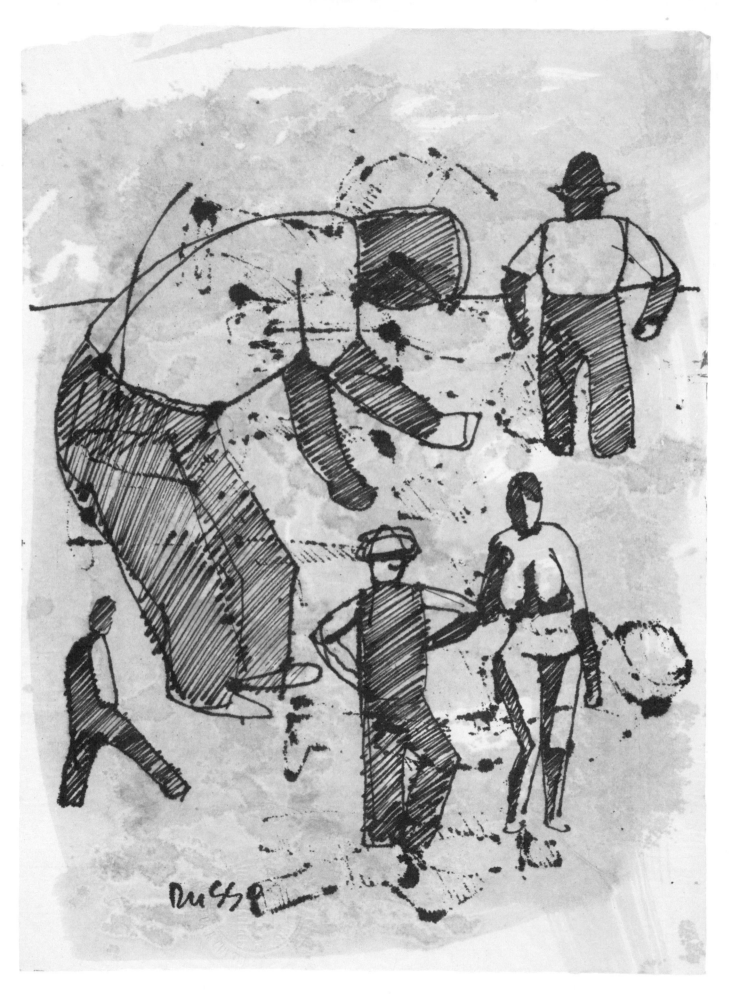

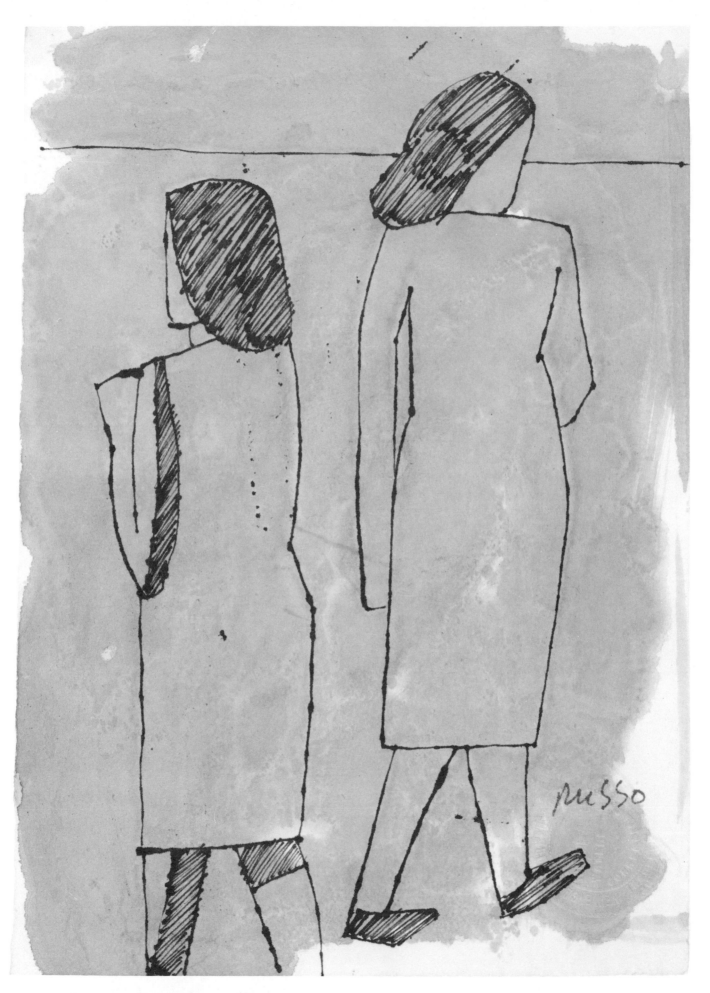

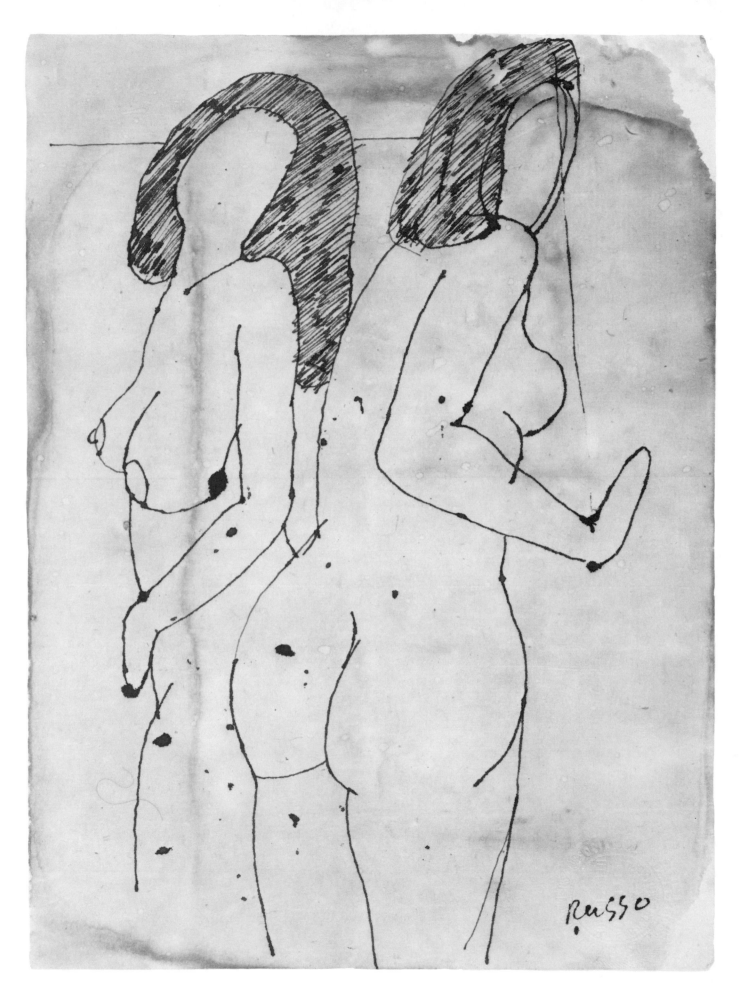

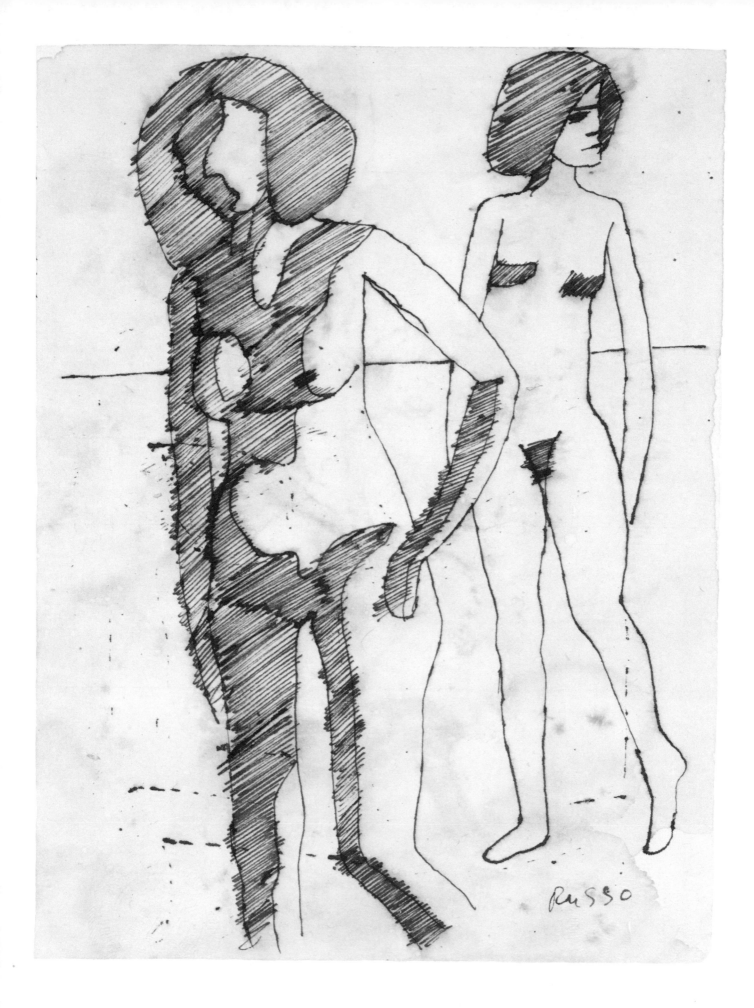

Russo

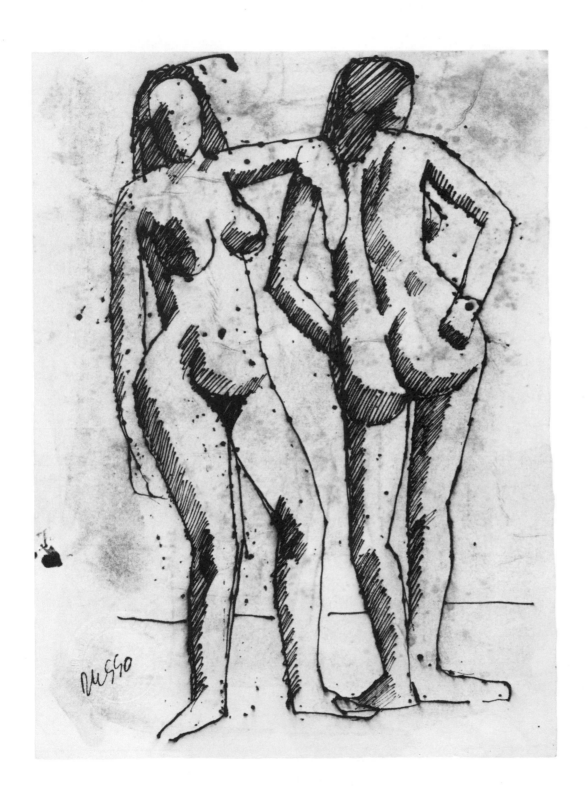

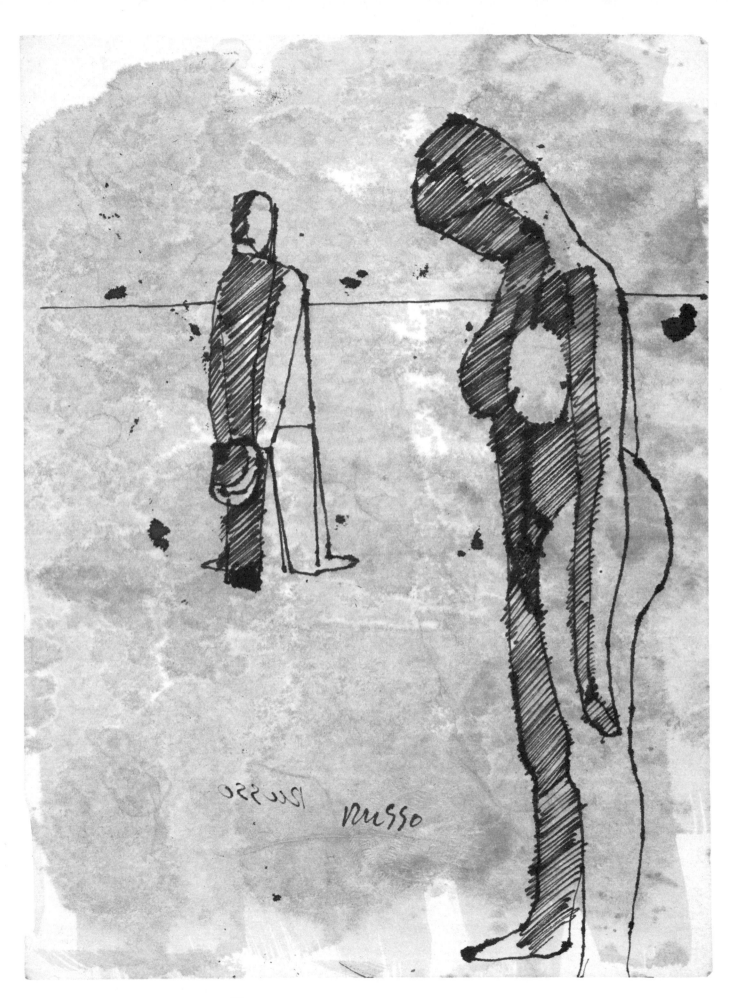

53

IV. Substance and Form [54-71]

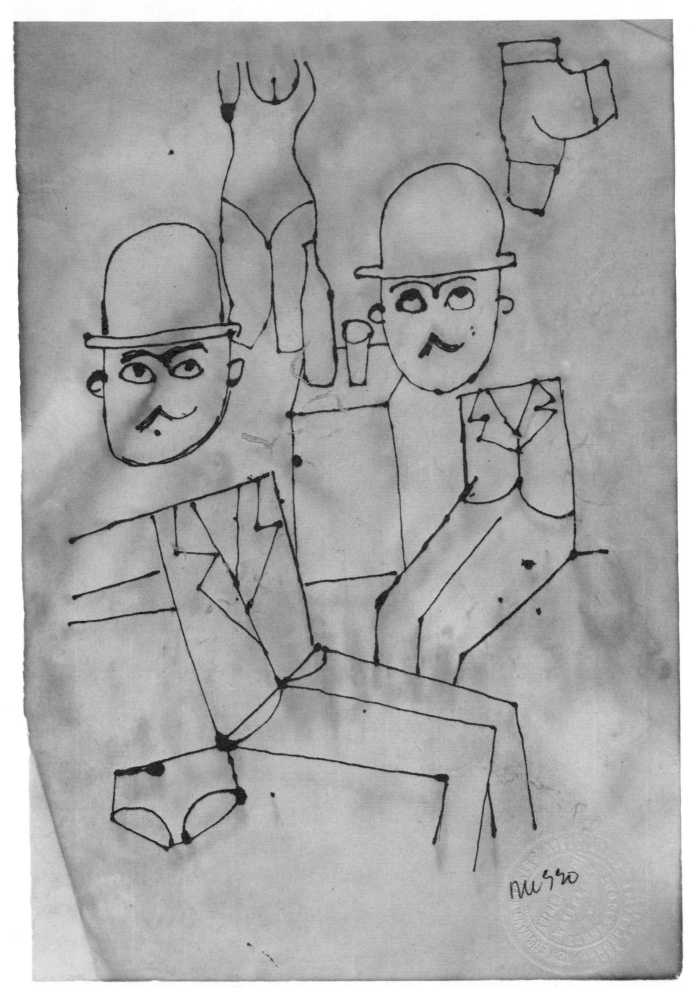

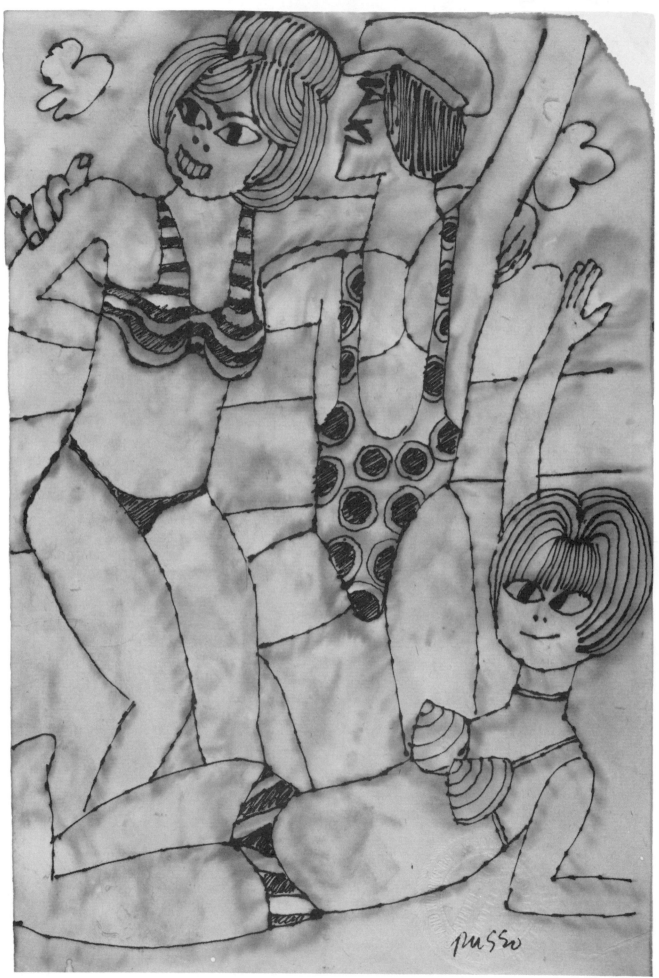

55

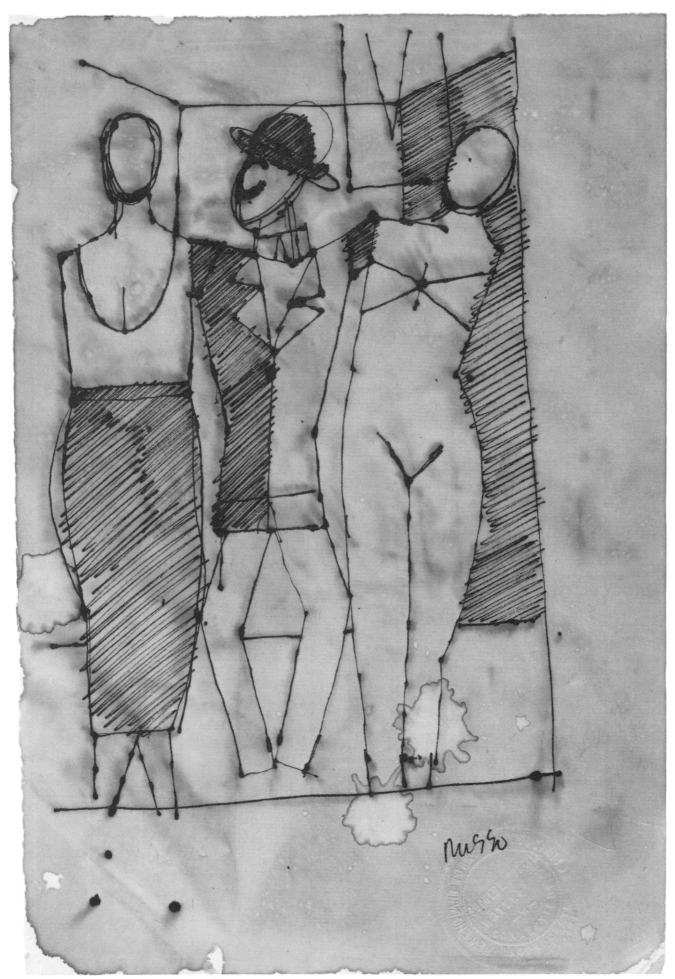

56

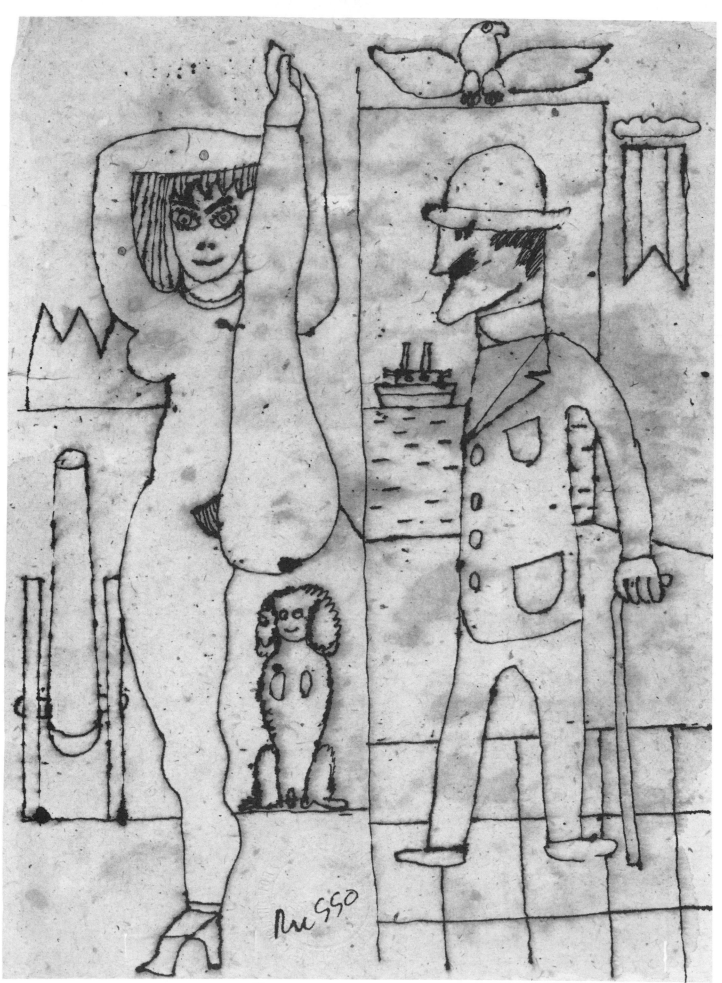

57

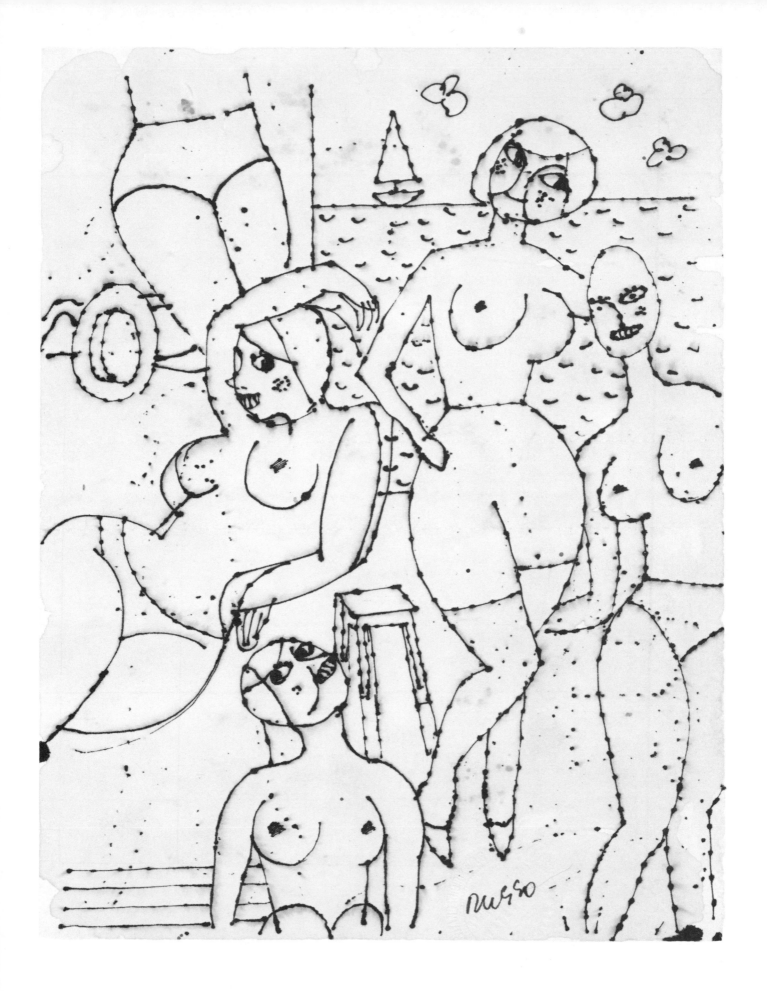

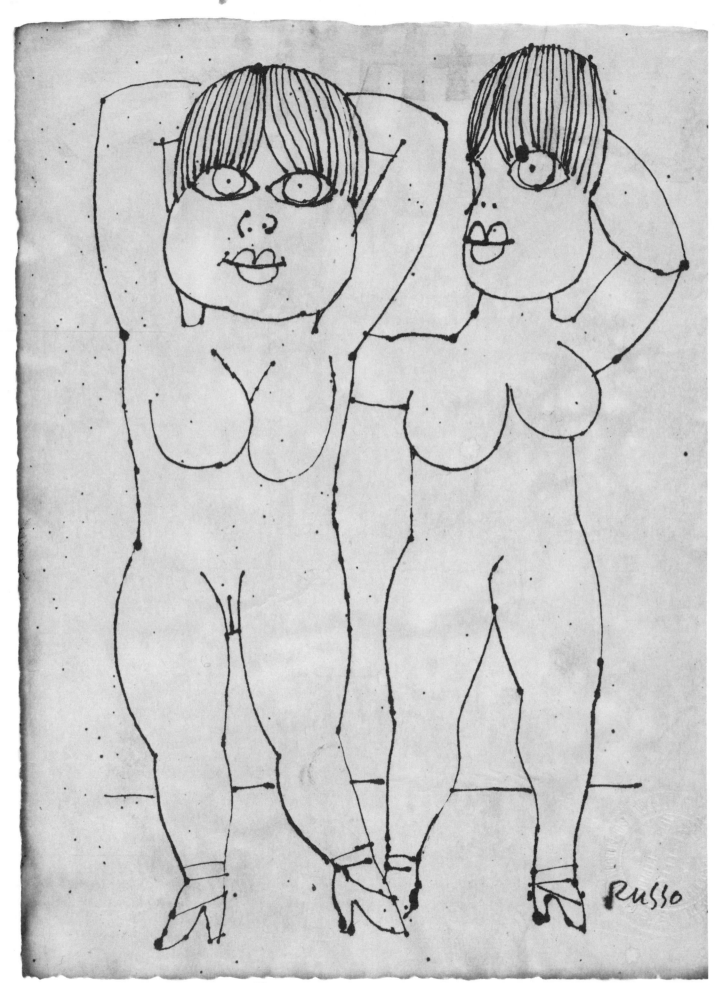

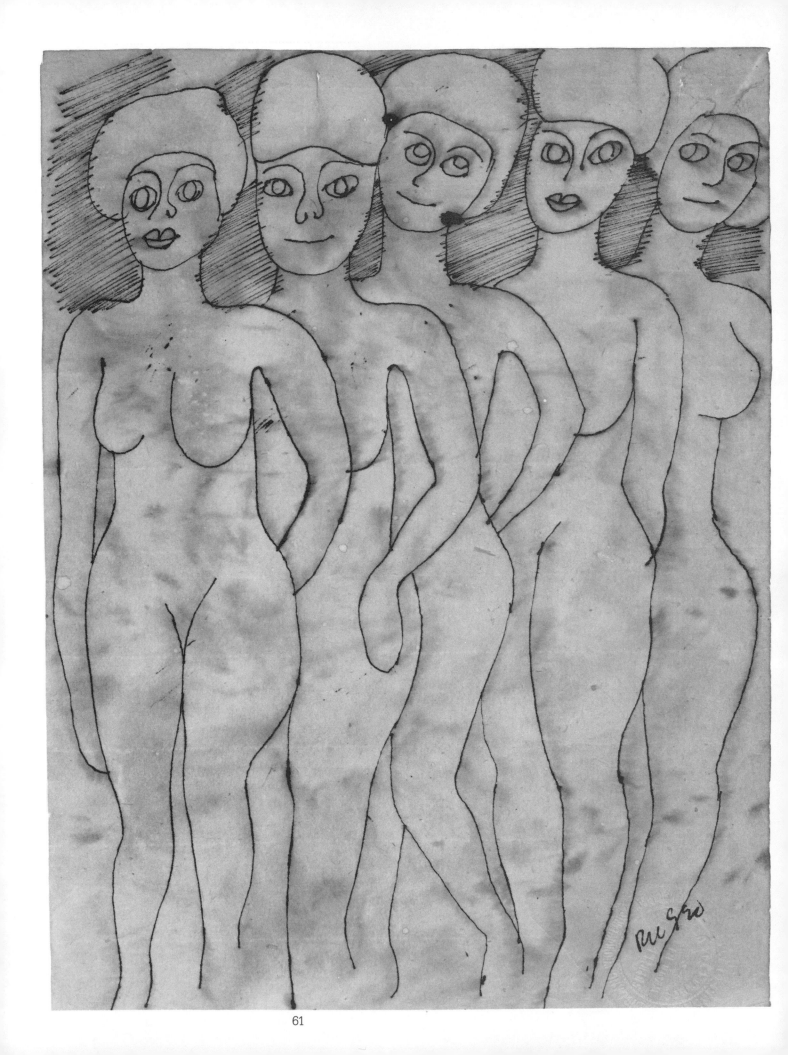

61

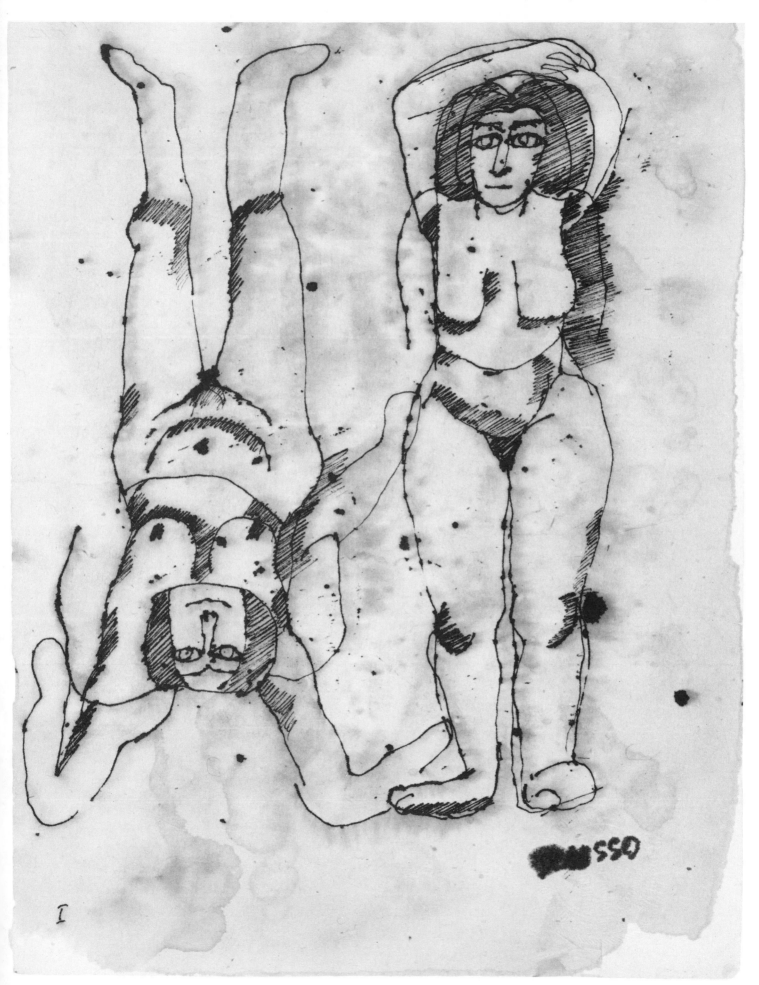

I

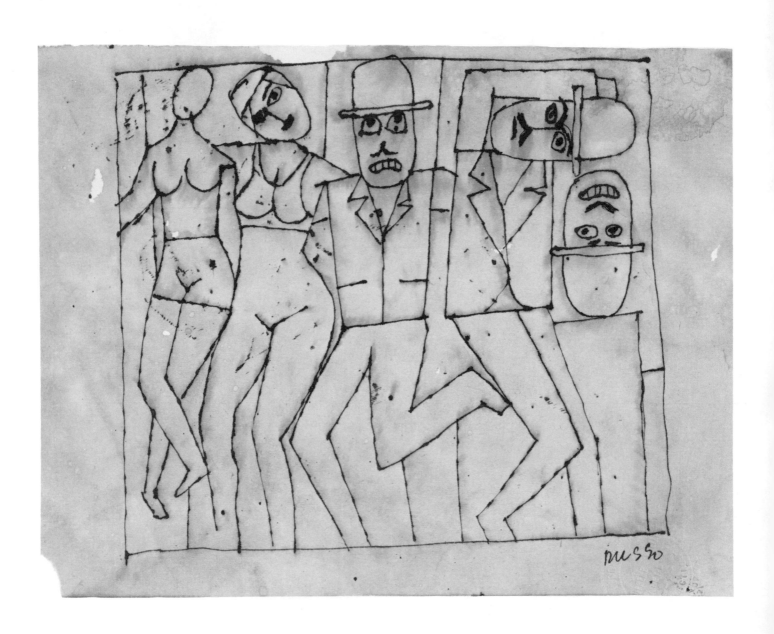

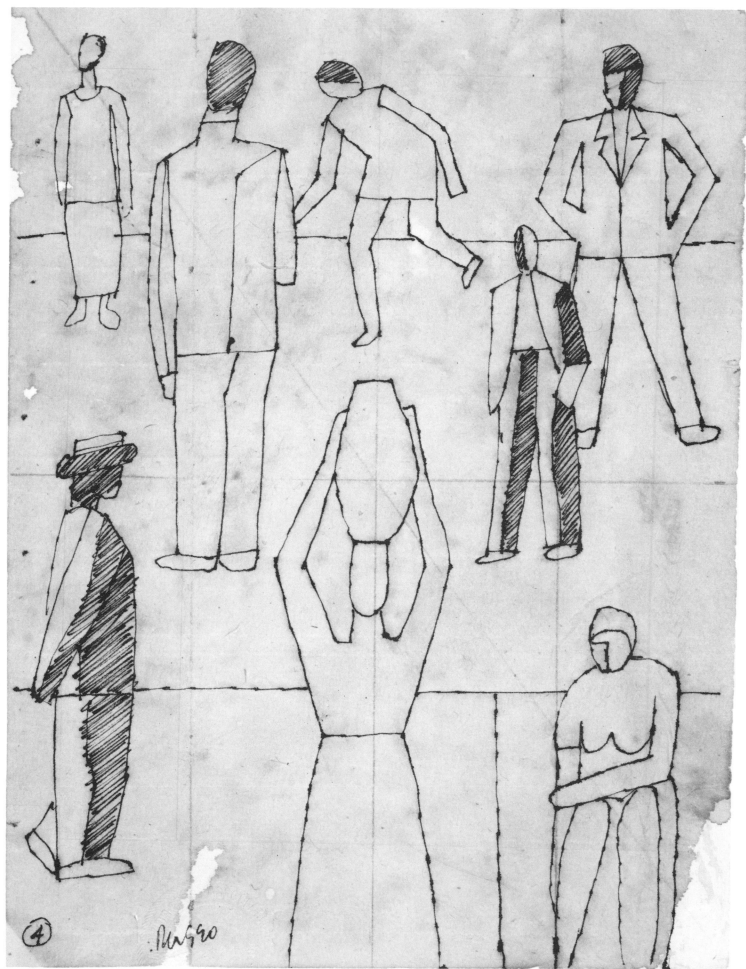

④

64

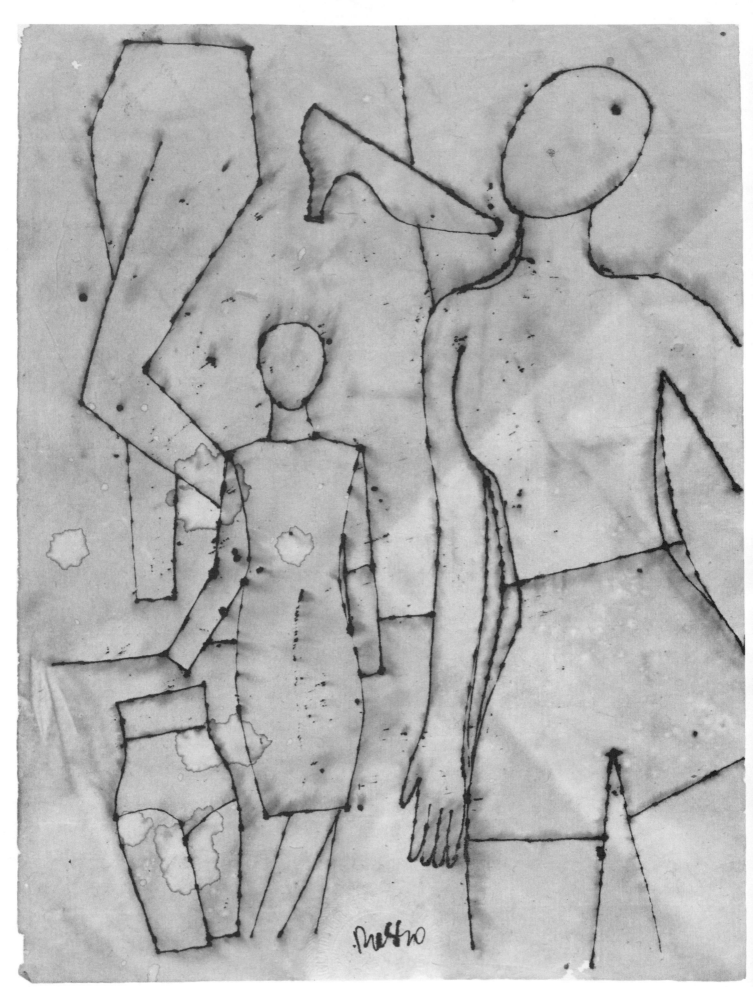

65

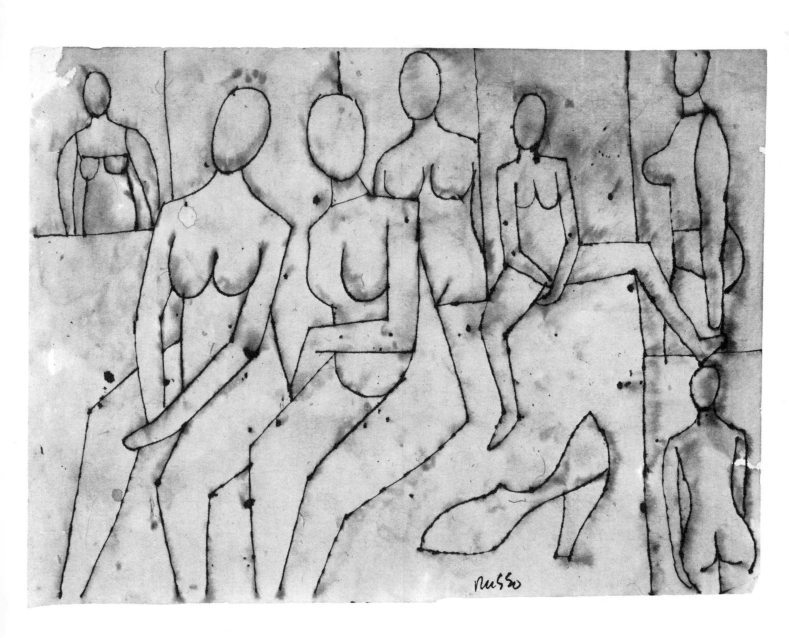

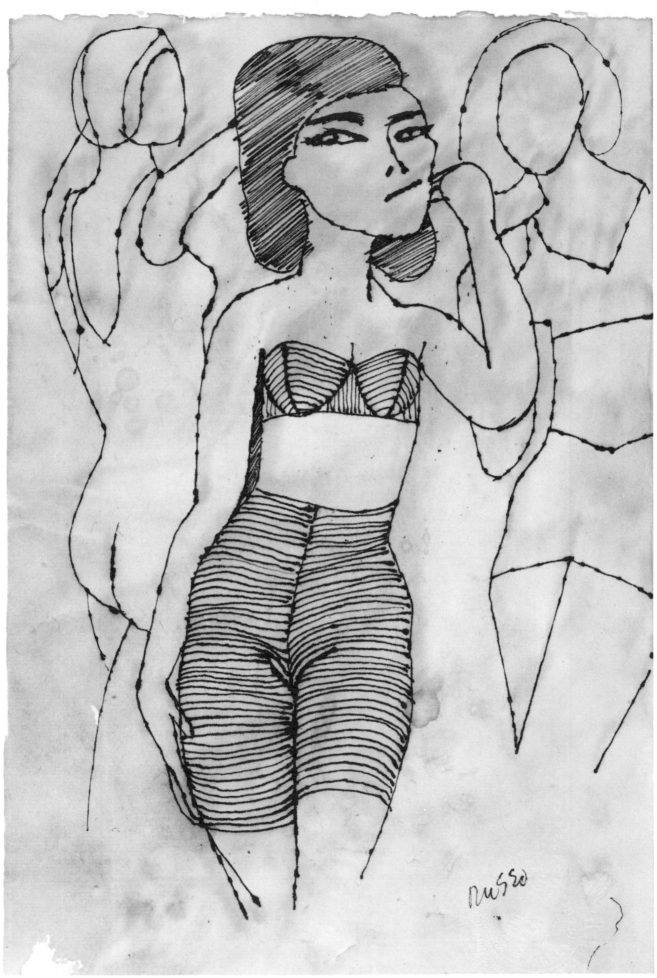

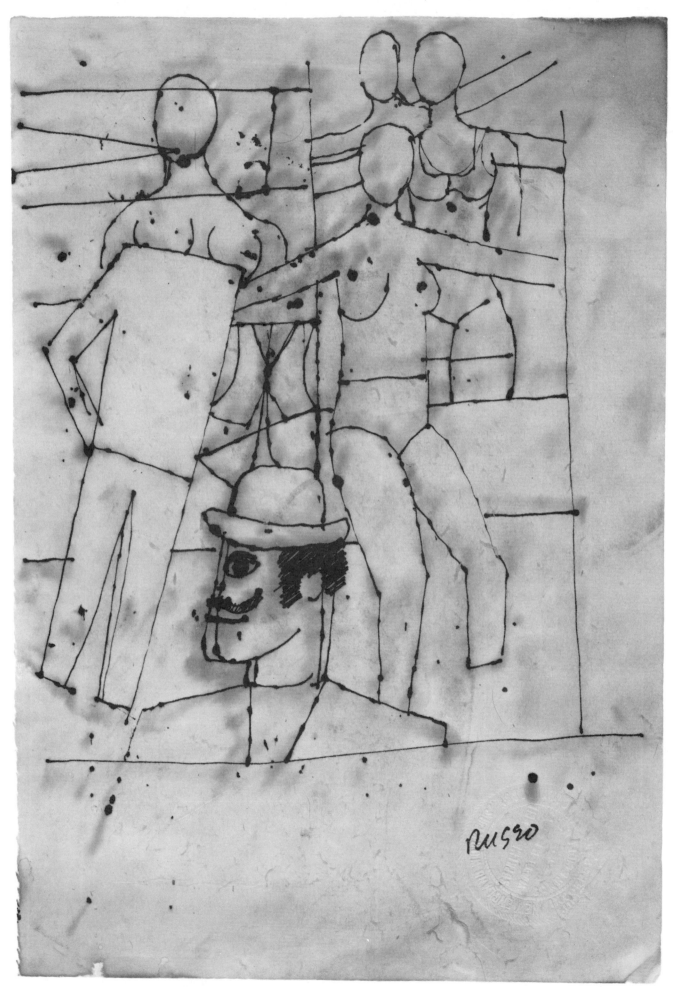

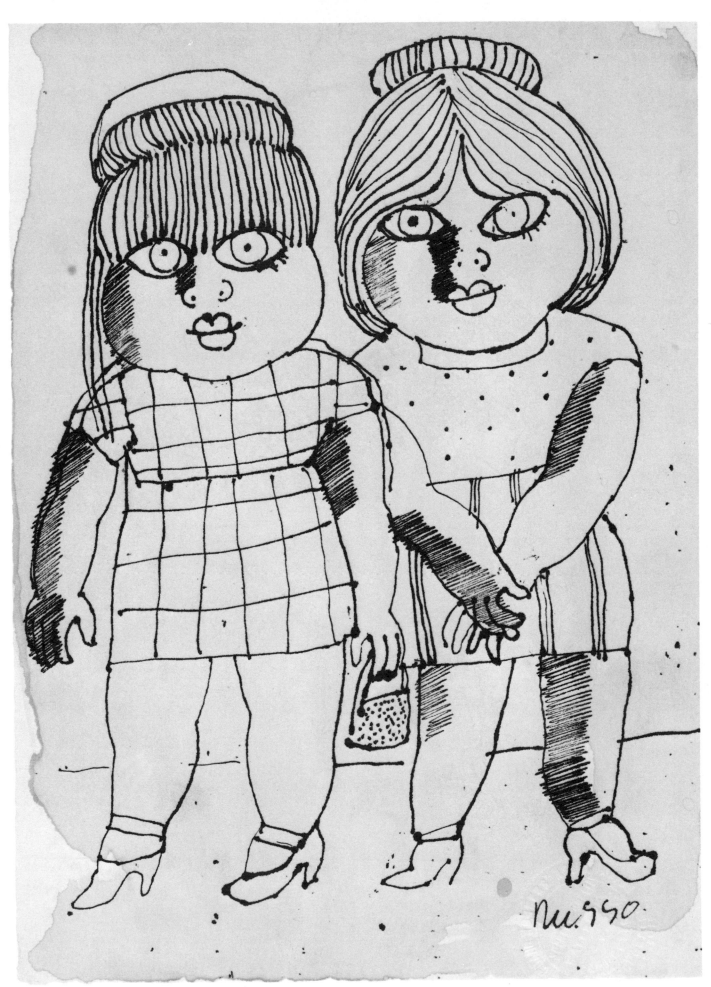

69

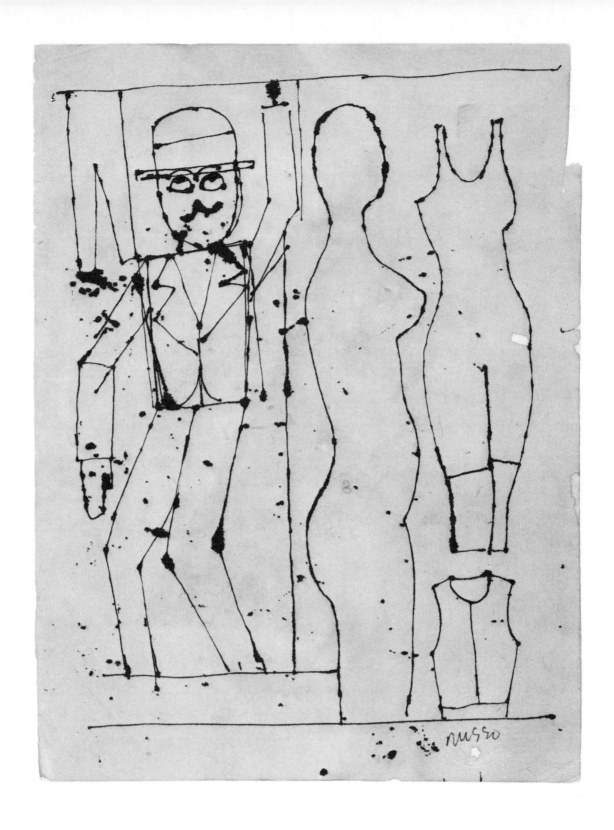

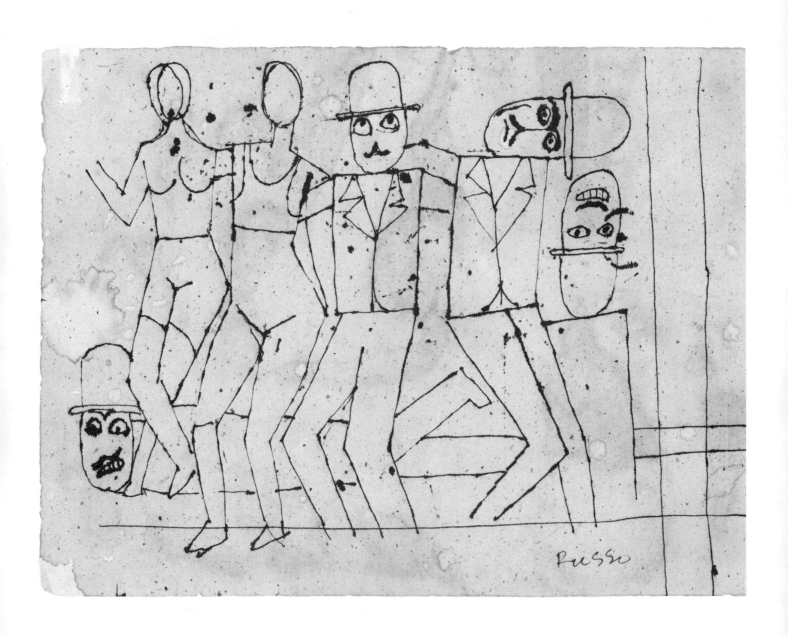

V. Mockeries, Ecstasies, and Other Nutrients [72-87]

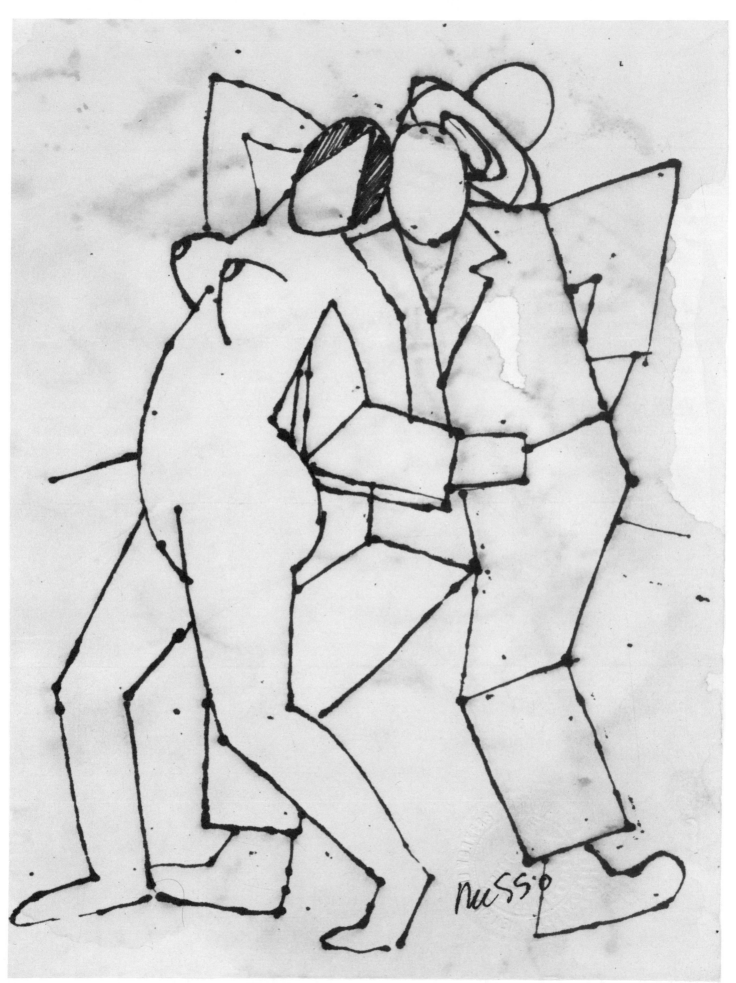

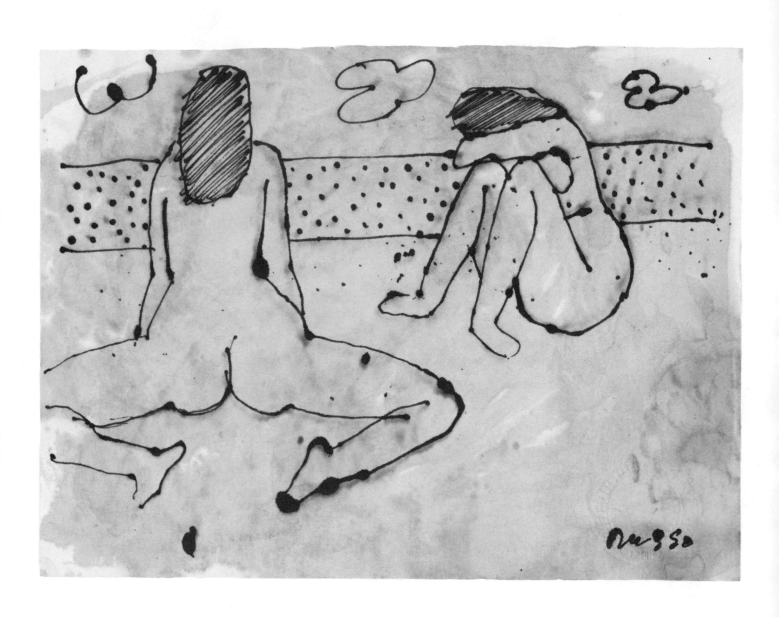

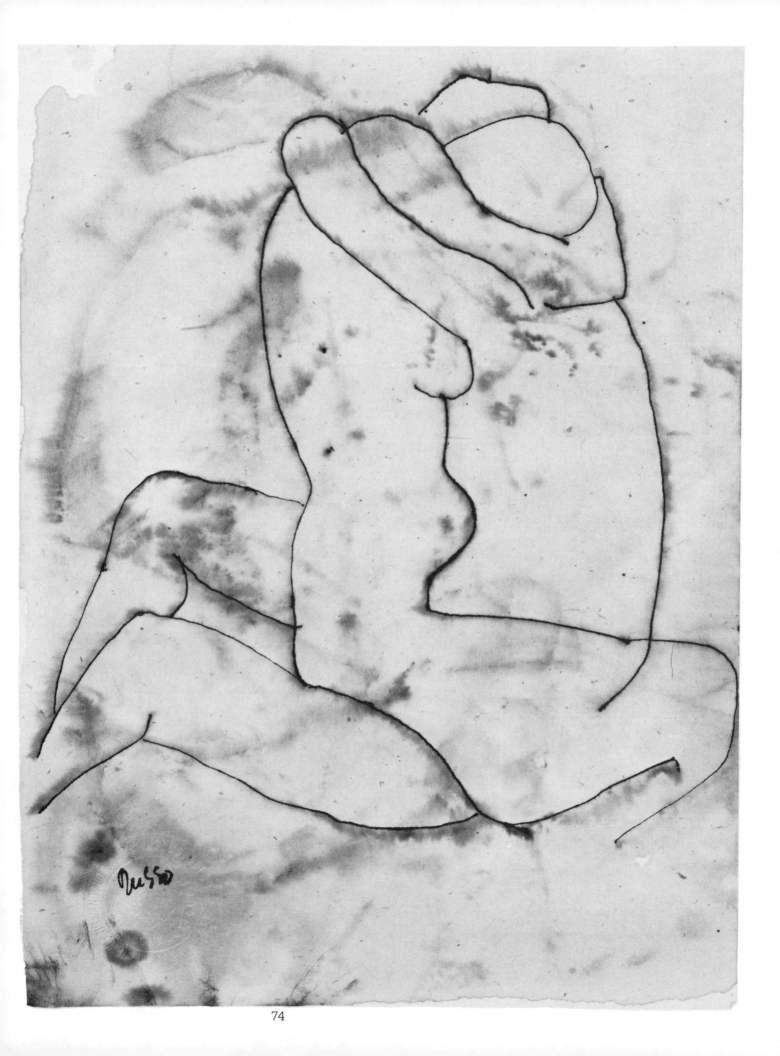

74

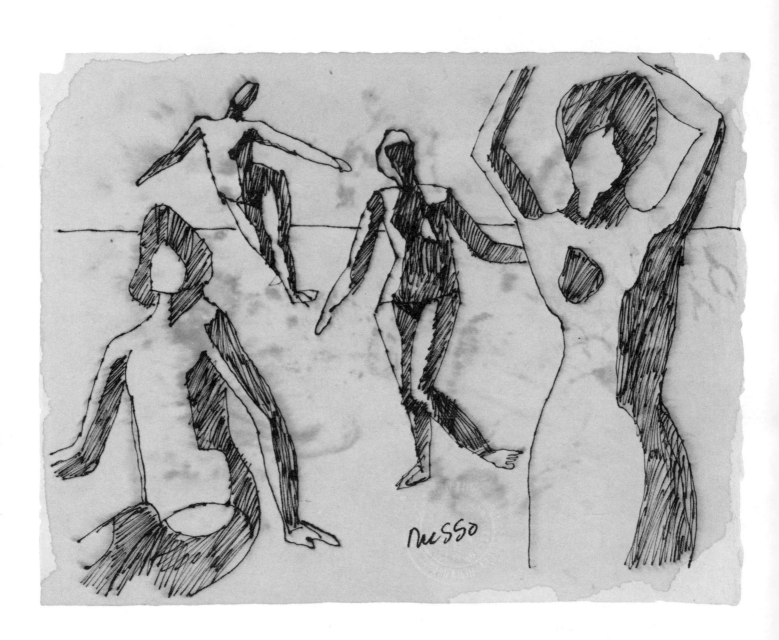

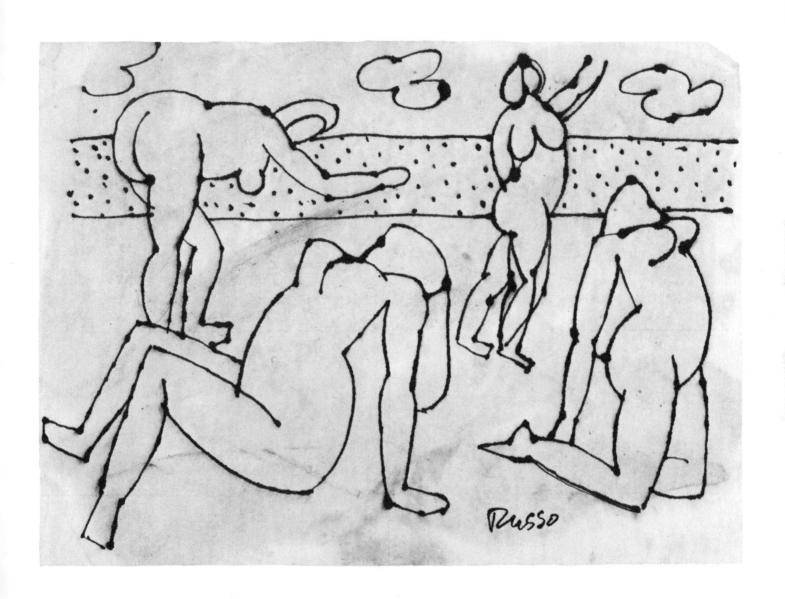

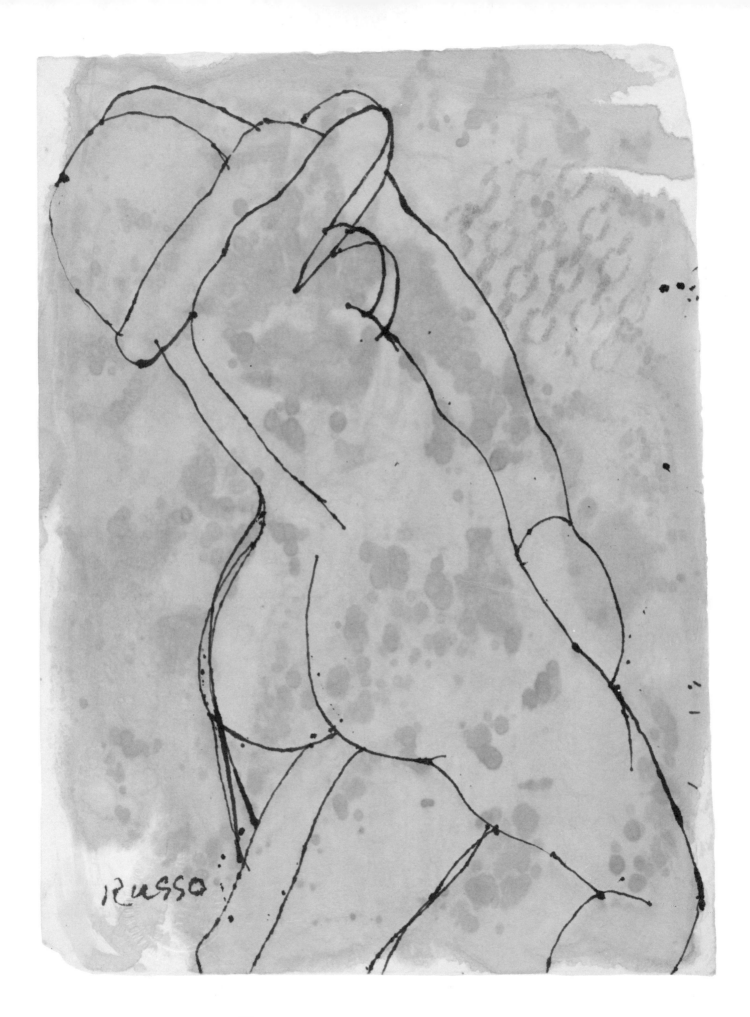

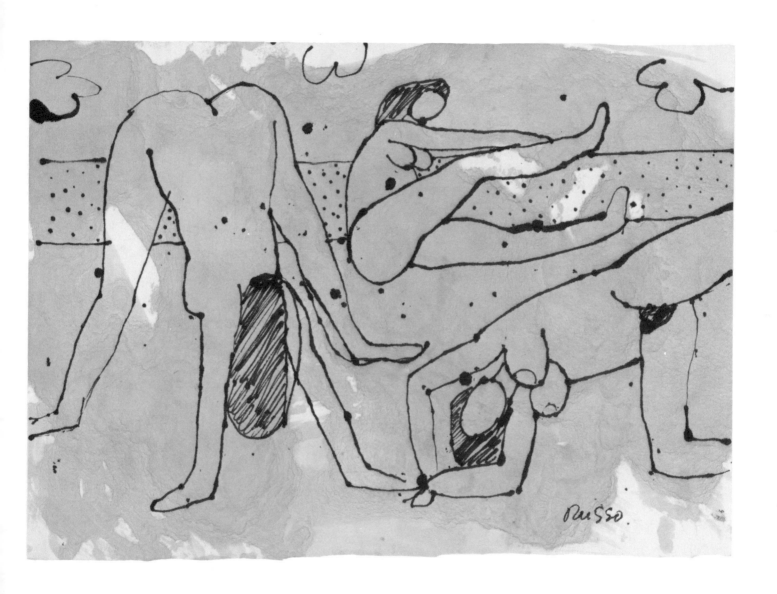

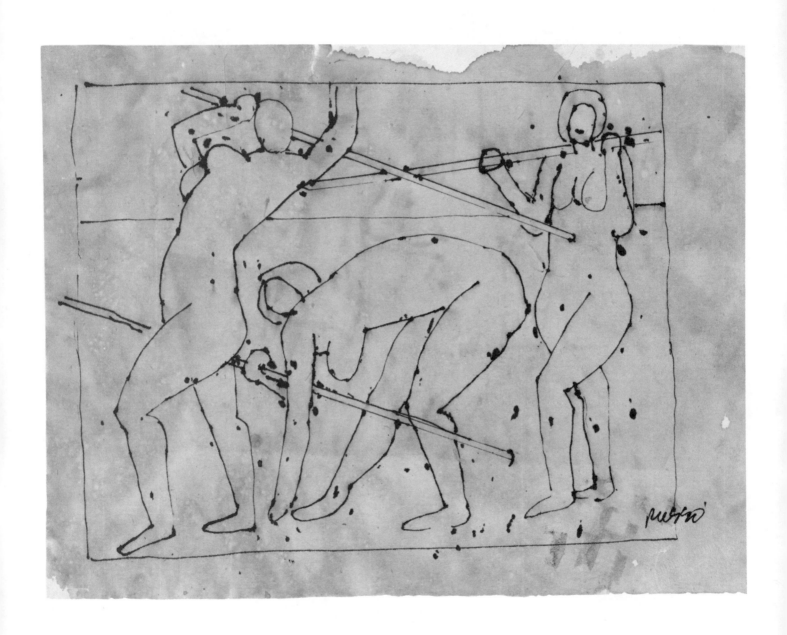

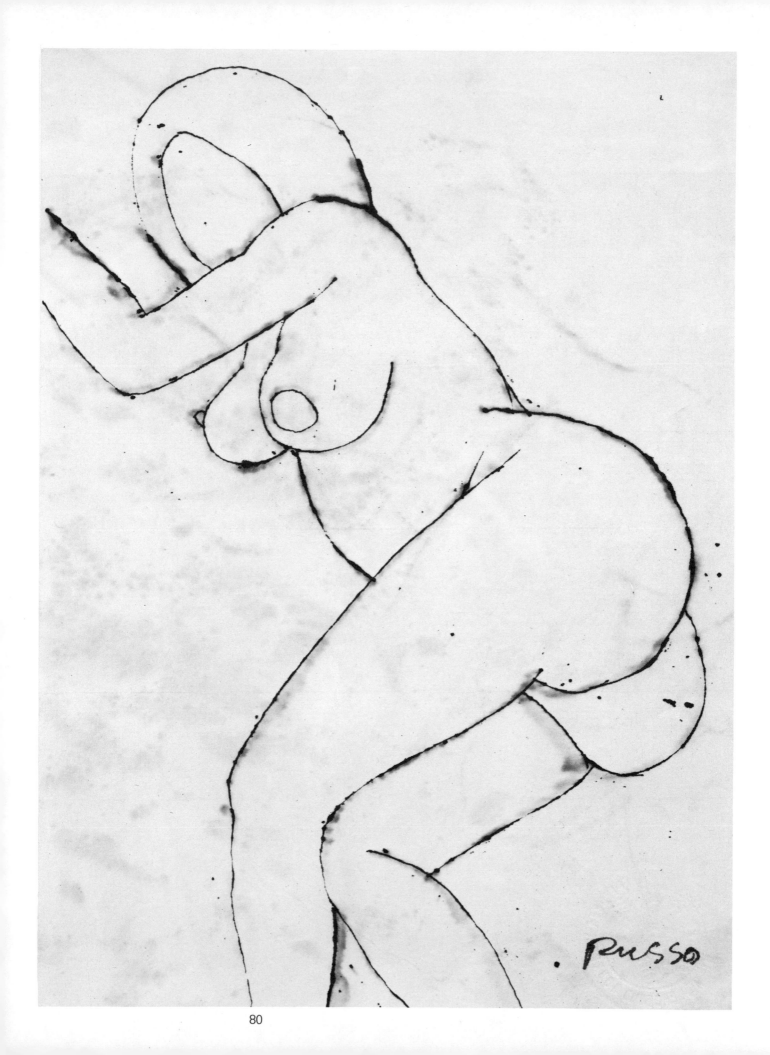

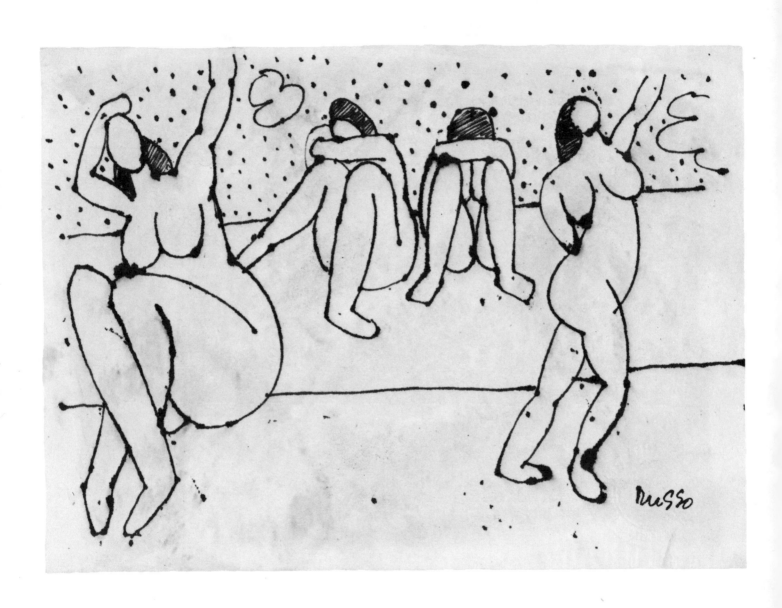

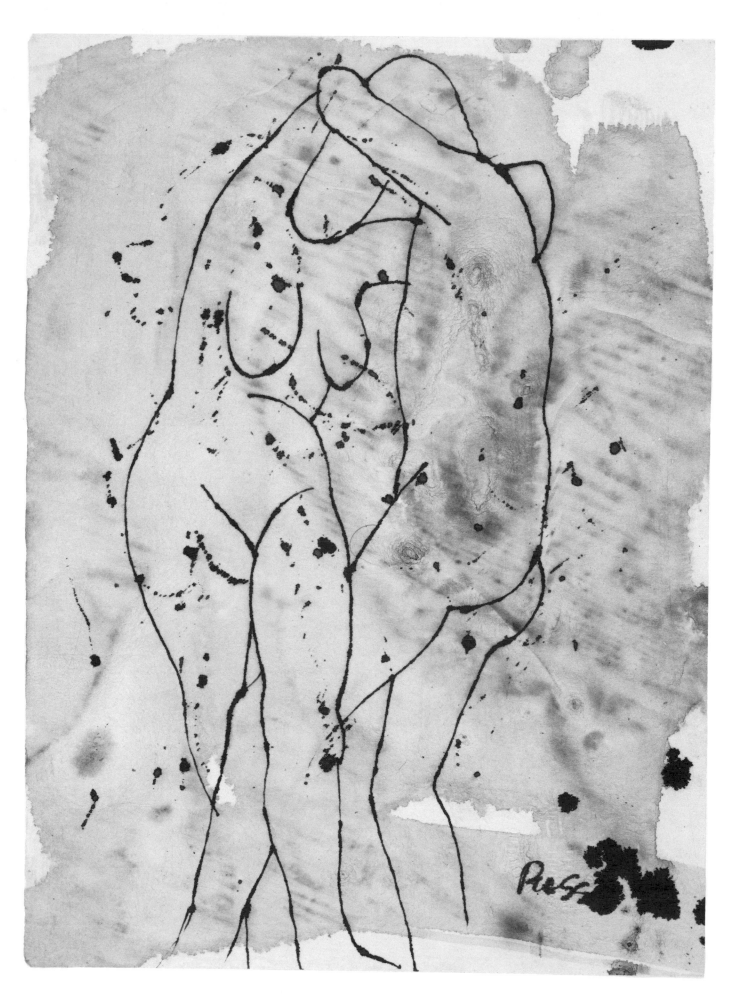

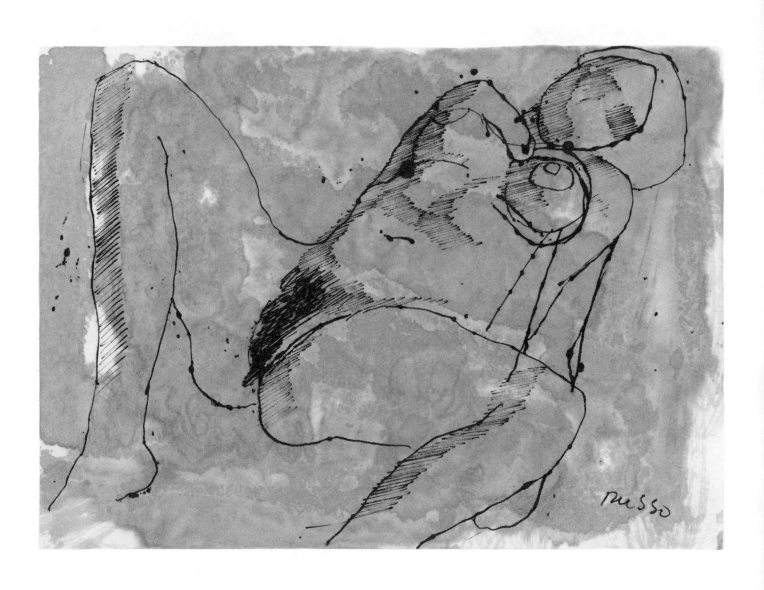

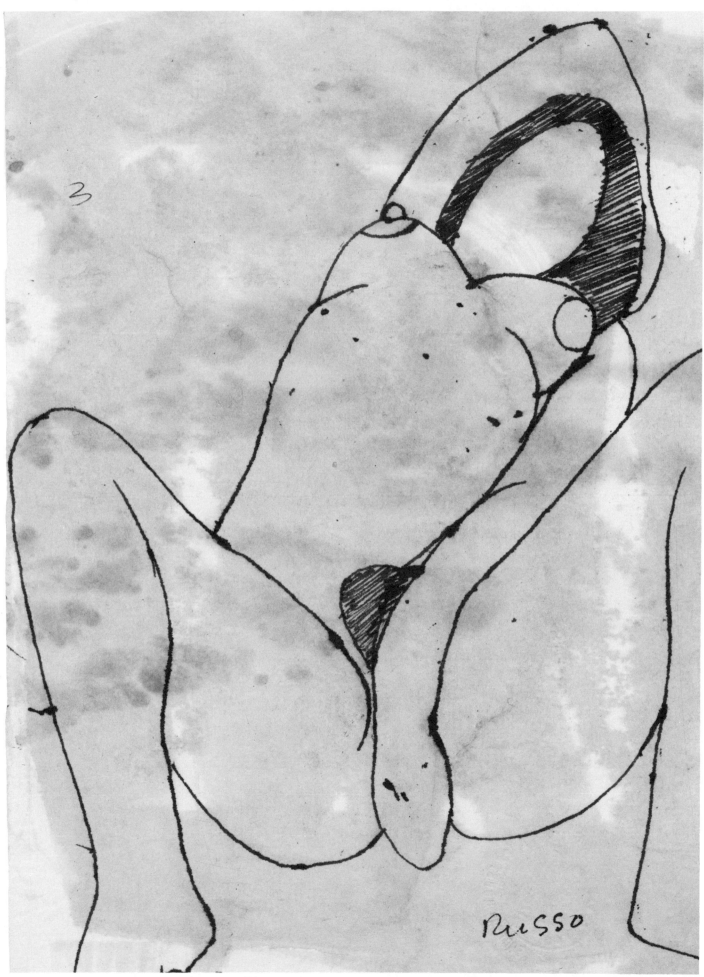

3

Russo

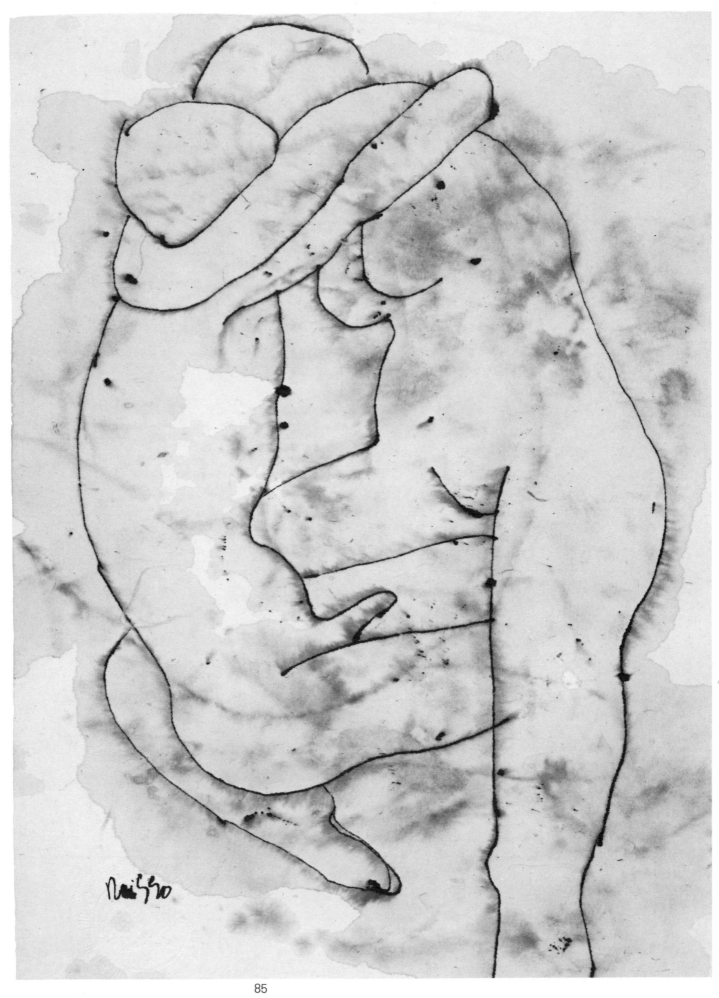

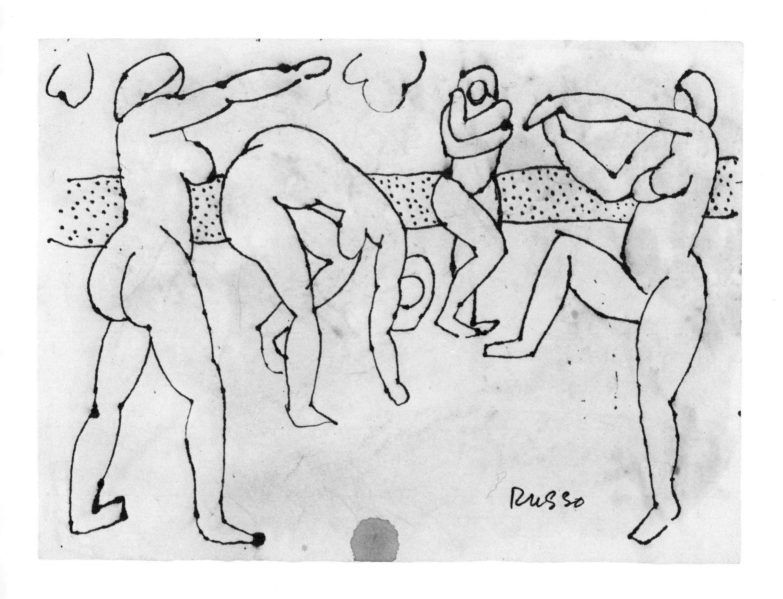

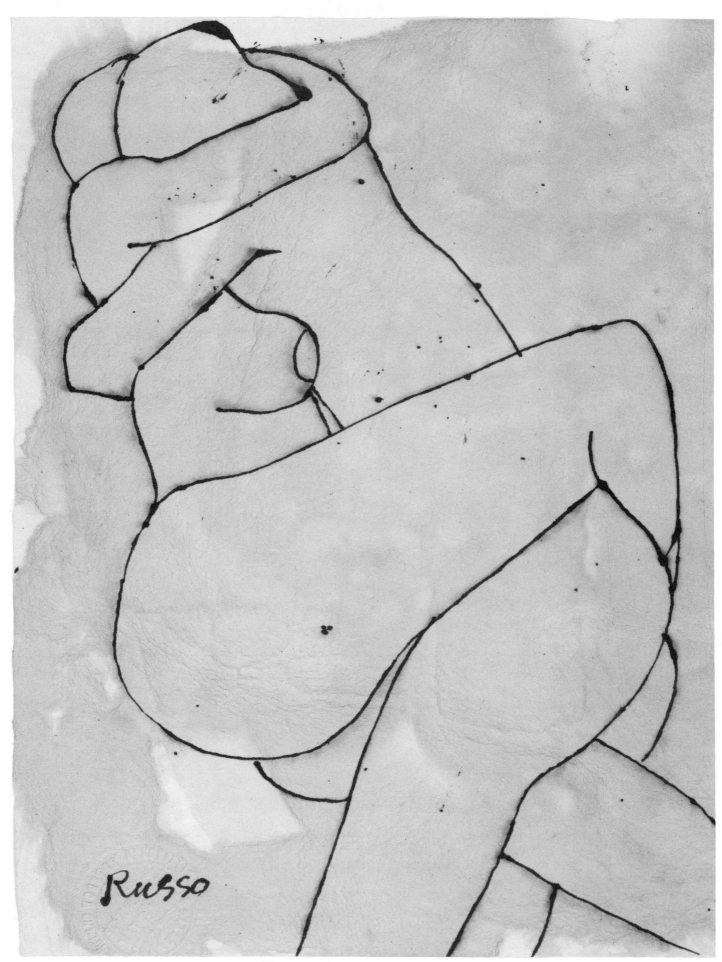

VI. Symbols, Icons, and Rituals [88-100]

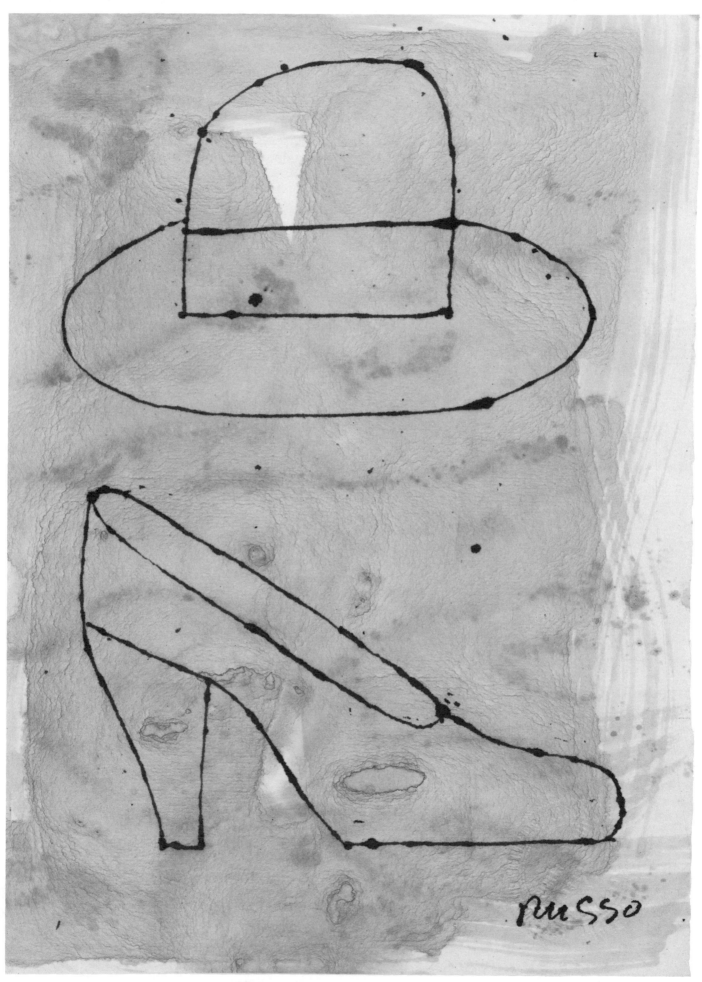

russo

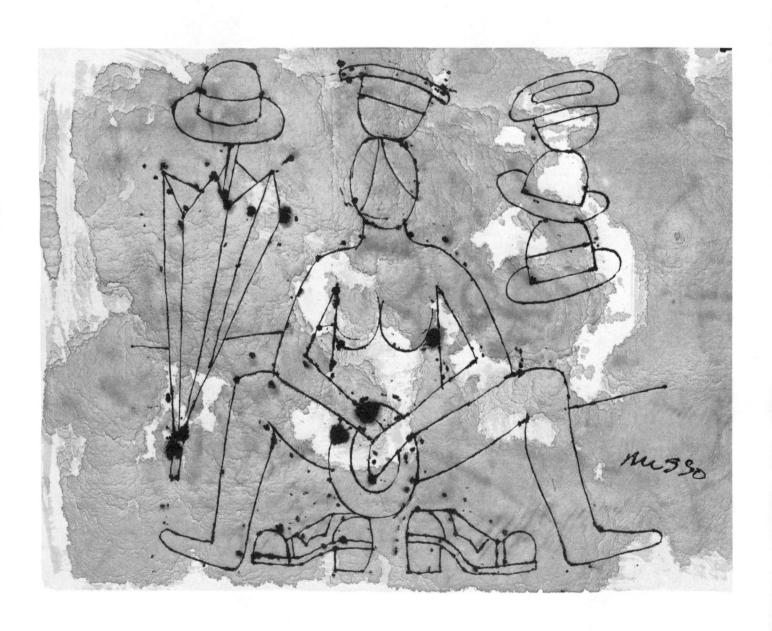

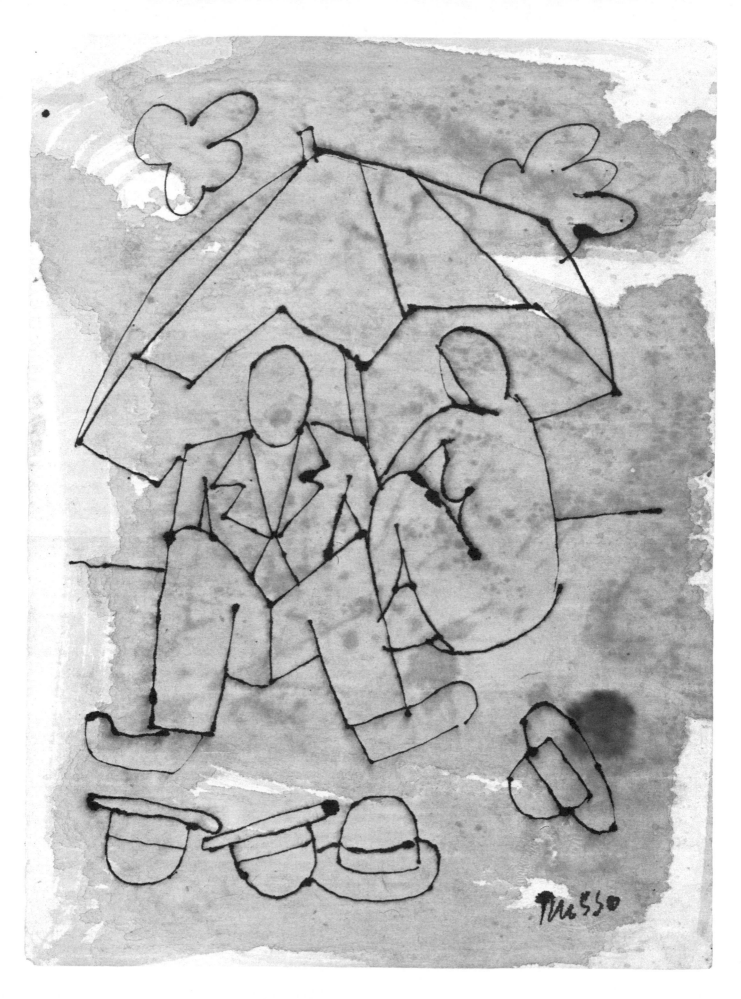

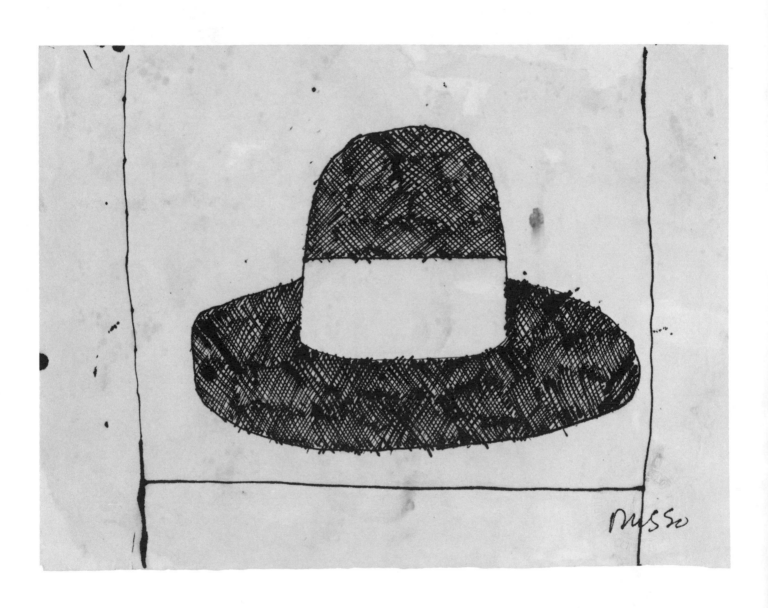

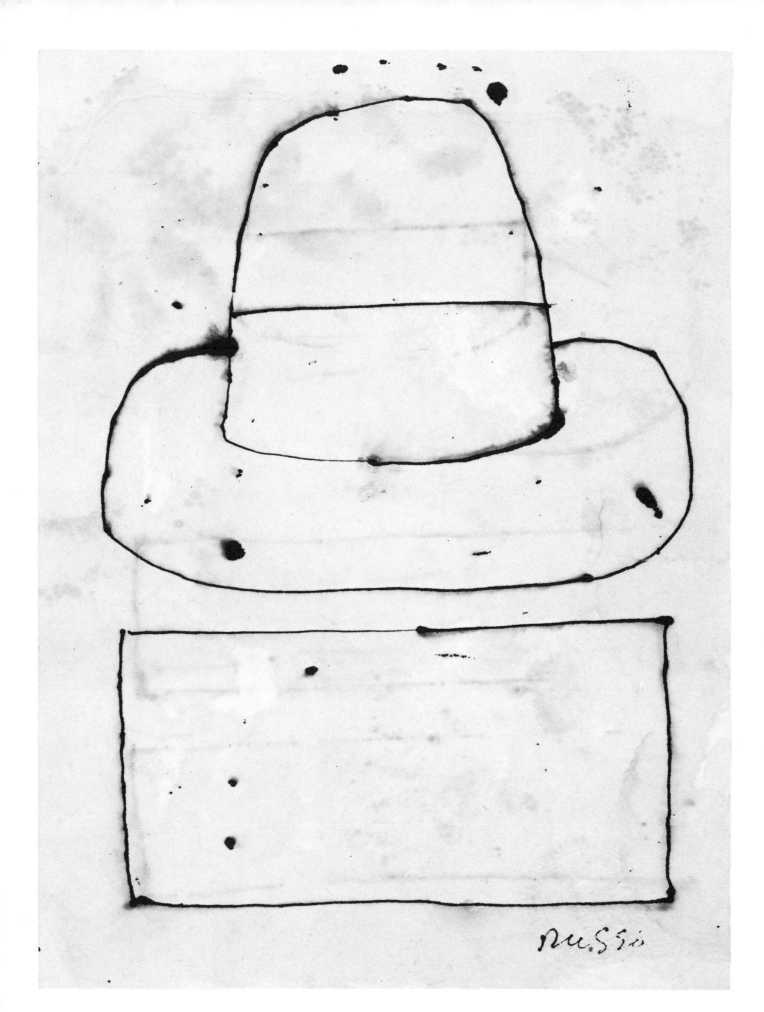

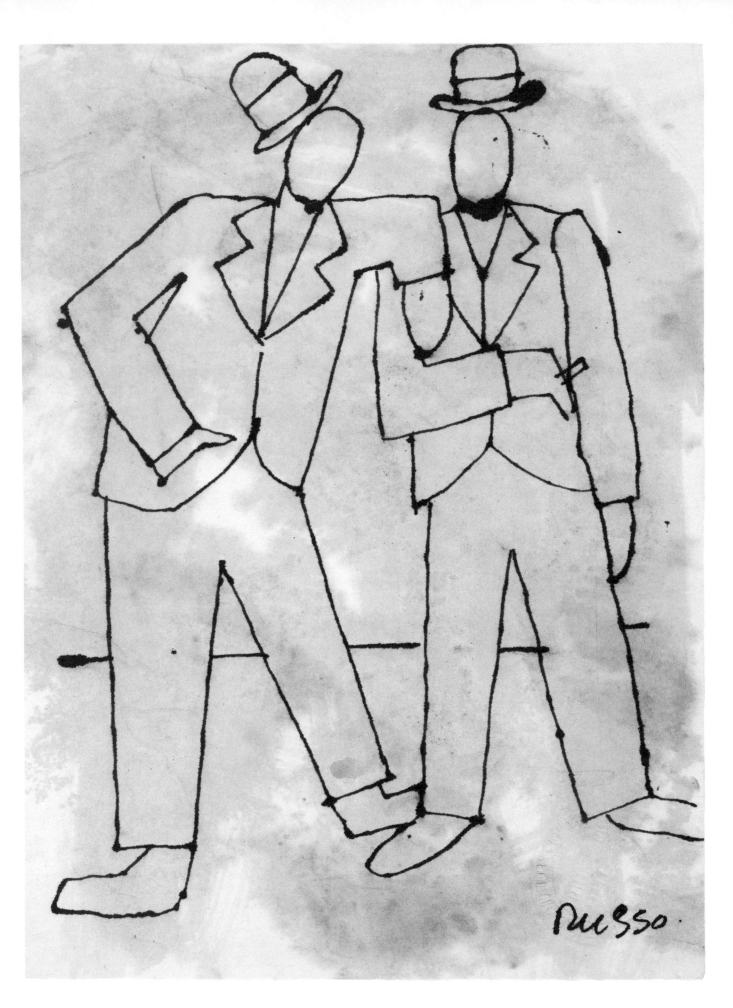

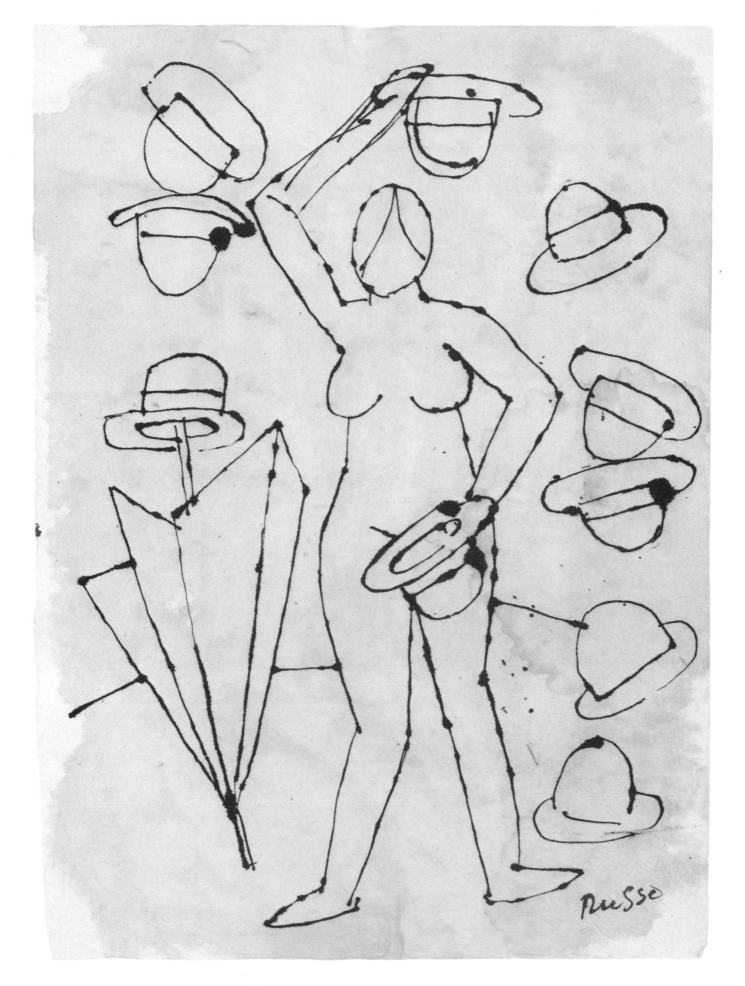

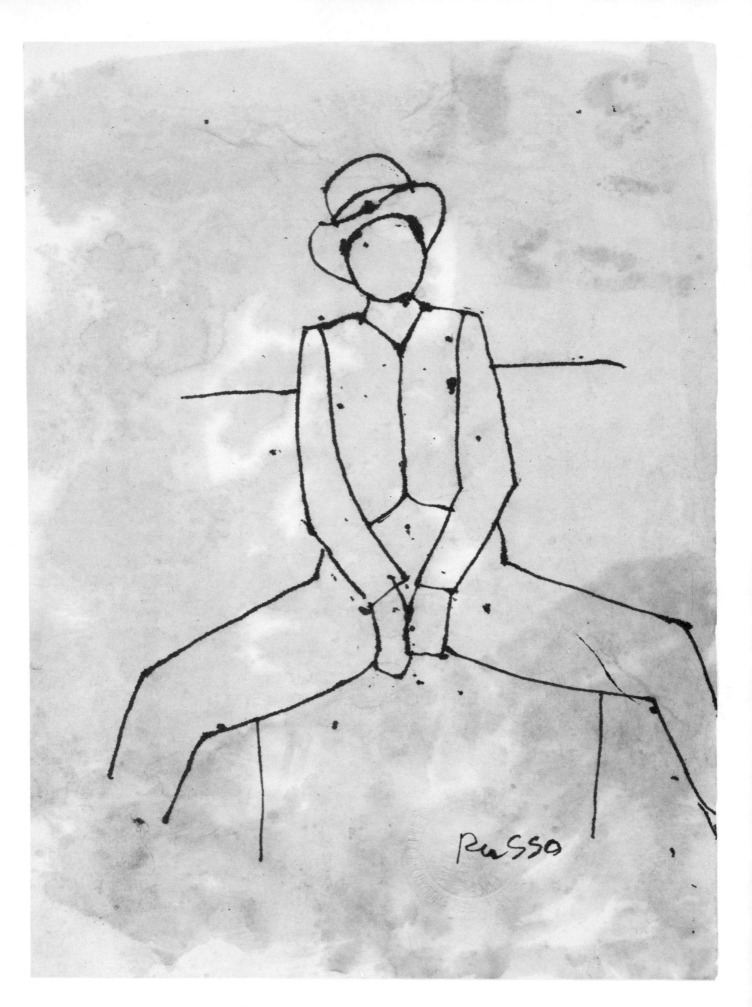

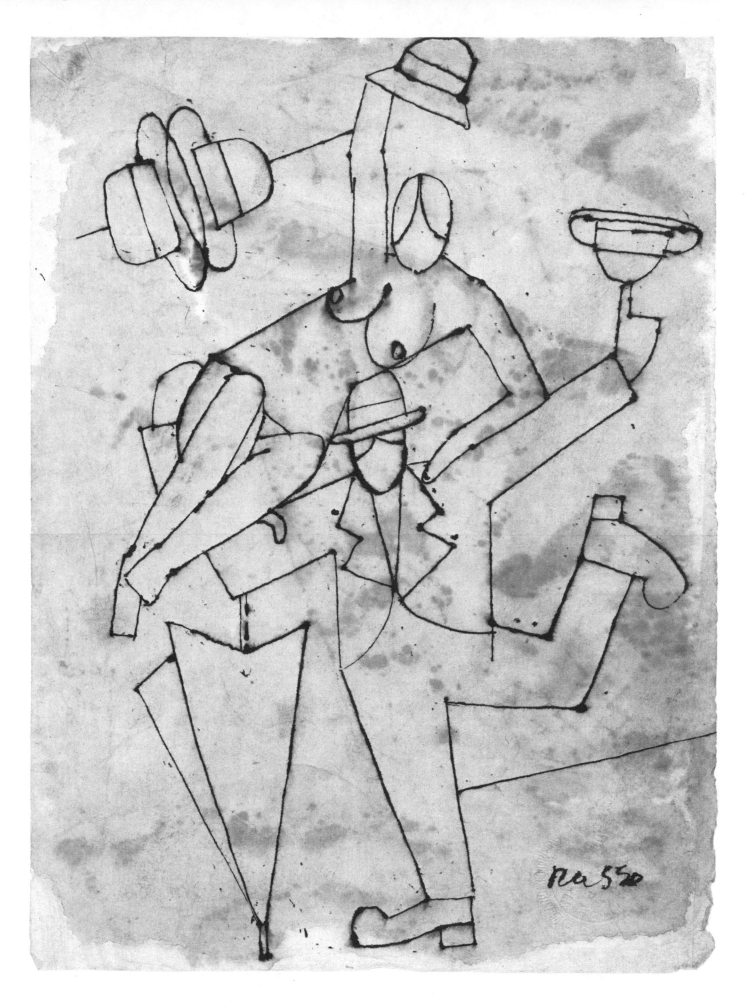

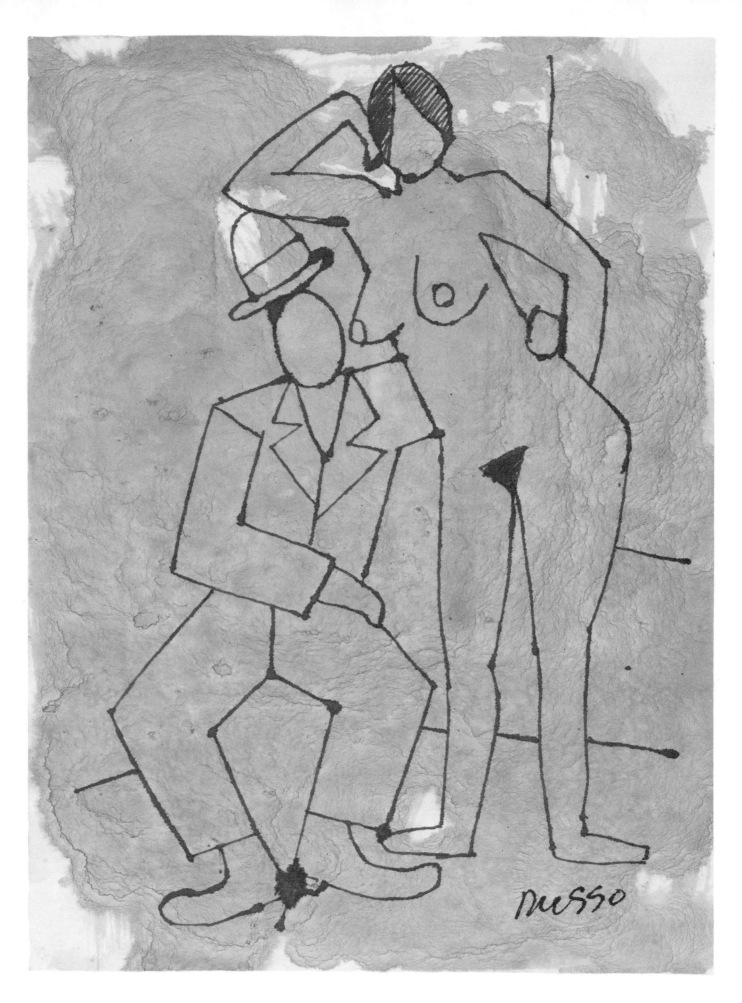

97

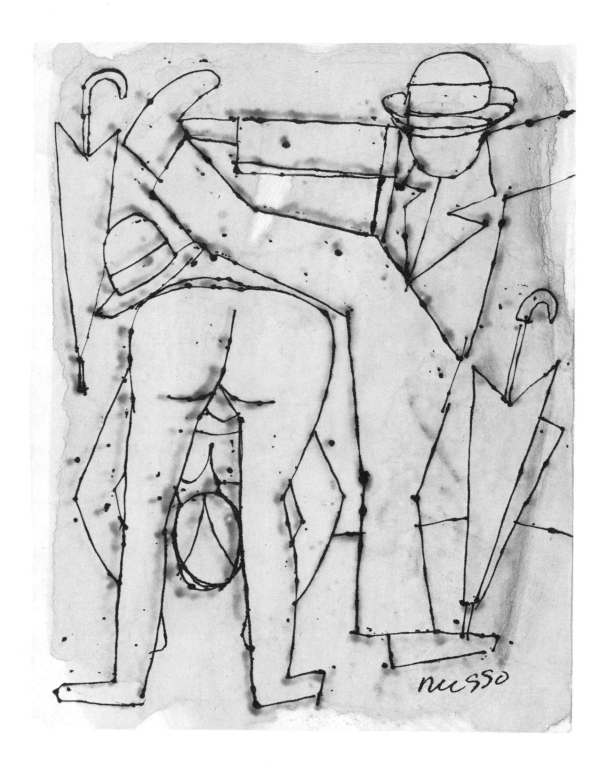

MICHELE RUSSO
Biographical Summary

1909: Birth of Michele Russo in Waterbury, Connecticut
1934: Graduation with Bachelor of Fine Arts Degree from Yale University
1935: Marriage to Sally Haley, employment with WPA for state of Connecticut
1937: Fellowship to Colorado Springs; birth of son, Michael
1940: War-time employment as artist-technician at U.S. Rubber Company
1947: Acceptance of Faculty Position with Portland Art Museum School
1950: Birth of son, John
1958: Participant in the founding of Artists' Equity in Oregon
1961: Participant in the founding of the Fountain Gallery, Portland
1973: Participant in the founding of the Portland Center for the Visual Arts
1974: Retirement from the Portland Art Museum
1977: Appointment to the Portland Metropolitan Art Commission
1979: Recipient of the Governor's Award for the Arts

MAJOR EXHIBITIONS:
(selected)

Portland Center for the Visual Arts, one man show 1978
Portland Center for the Visual Arts, invitational 1977
Seattle Center, World's Fair Exhibition, Washington 1962
Smithsonian Institute, Washington D.C., *Art of the Pacific Northwest* 1974
Fountain Gallery, one-man shows 1963, 1968, 1971, 1975, 1977, 1978
Santa Barbara Museum of Art, California, *Pacific Coast Invitational* 1963
Colorado Springs Fine Art Center, *Artists West of the Mississippi* 1936
Portland Art Museum, group show 1953
Portland Art Museum, one-man retrospective 1966
Kraushaar Gallery, "Eight Oregon Artists," New York 1952
Reed College, one and two-man shows 1951, 1952, 1959

PUBLIC COLLECTIONS:
(selected)

Fred Meyer Savings and Loan, Portland, Oregon
Hilton Hotel, Portland, Oregon
Equitable Center, Portland, Oregon
University of Oregon Art Museum, Eugene, Oregon
Seattle Art Museum, Washington
Reed College, Portland, Oregon
Smithsonian Institute, Washington, D.C.
Pacific Northwest Bell Company, Seattle, Washington
Rainier National Bank, Seattle, Washington
Emanuel Hospital, Portland, Oregon